Dedication

To Nadra. Thank you for all the love and support.

Acknowledgments

I would like to thank all the people who took the time to help me with the book.

Scott Diussa, Mark Suban, Mark Kettenhofen, and Brien Aho for the great instruction and inspiration during the Nikon Video School.

Rick Sammon and Chuck Westfall for the Canon answers. Brian Smith for Sony help. Erika Thornes for answering questions about both the Sony and Canon camera systems.

A good camera store is one where you can go to get cameras, lenses, and gear. A great camera store is where you can go to get camera gear plus information and help, *and* just discuss the current state of photography. I live in a town that has a couple of great camera stores. I can't thank the whole staff over at Nelson Camera enough for the use of some loaner gear and support while I finished this book.

Thanks to Jerod Foster for the use of the some Canon lens images. You can check out his work at www.jerodfoster.com.

Thank you to the amazing team I get to work with at Peachpit for their hard work and quick turnaround during the writing process. I could not have done this without Valerie Witte, Linda Laflamme, Danielle Foster, Patricia Pane, and Valerie Perry. Thank you to Sara Jane Todd and Sheila Lease for all your hard work in getting this title into the hands of photographers.

Thank you to my friends and family for understanding the crazy writing schedule.

Finally, a *huge* thanks to my wife for her love, support, and patience. It is not easy to deal with me when I'm writing a book, especially when I turn parts of the house into a makeshift studio for just one more photo. Thank you. I would not be able to do this without you.

Alan Hess
San Diego, CA
December 2015

Contents

Introduction

When I started to take photographs many years ago, there was no autofocus. I used to have to manually focus by turning the focusing ring on the lens until the image in the viewfinder was sharp. Only then could I start trying to compose the image in a pleasing way. Then along came autofocus, and the camera seemed to magically focus faster and better than I could. Taking photos became a lot easier. Autofocus has made it easier to take sharp, in-focus photos, but camera manufacturers keep trying to make the autofocus faster and better while giving photographers a lot more options. These options also make it a lot more complicated for photographers, especially for those just starting out with DSLRs.

Q: Why focus and autofocus?

A: With the advances in autofocus, photographers can get caught up in the technical settings and end up either missing the shot or getting a photo that is close, but not quite what they intend. Once you master the focus settings on your camera, however, you can concentrate on capturing your vision of the subject without continually worrying whether the image is sharp.

One of the things that prompted me to write *A Photographer's Guide to Focus and Autofocus* was a photo I saw at a job. It captured a great moment, but the focus was off. The image bothered me. The greatness of the moment couldn't thoroughly shine, because the photo was just not as good as it could have been. The photographer failed to get the focus quite right. In writing this book, I wanted to share tips and information to help you master the focus settings, so you can capture your own great moments exactly the way you envision them.

Q: Who should read this book?

A: If you want a better basic understanding of the autofocus capabilities of your camera, this is the book for you. Whether you're just starting out on your photography journey or have hit a roadblock to capturing sharp images, this book will help.

Q: What does this book cover?

A: Covering a lot of basic information, this book is meant to be an overview, not a camera-specific guide. I use Nikon cameras and the majority of images for this book were taken with Nikon gear, but I know that many of you use Canon and Sony cameras. I have done my utmost to make sure that the terms used in this book and the techniques shown can be used on any of the camera systems.

Remember, too, that not all cameras are created equal. Professional cameras cost so much more than the entry-level models for a reason. I tried to make sure that I covered the capabilities of all the cameras, but please understand that your camera might not have the same number of focus points as the Canon 7D Mark II or the Nikon D750. That doesn't mean you can't get a lot of use from this book or that your camera won't take photos that are as good as those taken with a professional camera. So when you're using this book, it will help to have the camera manual or a camera-specific book like those in the *Snapshots to Great Shots* series handy to find the specific controls on your camera. That said, here's a preview of what you'll find in *A Photographer's Guide to Focus and Autofocus*:

Chapter 1 gives you an overview of what to expect when using autofocus and when manual focus might be a better choice. It points out key techniques, useful features, and common scenarios that later chapters will revisit in more detail.

Chapter 2 is an overview of autofocus, covering some history and how autofocus works. You'll also learn the names used by Nikon, Canon, and Sony for their autofocus controls.

Chapters 3, 4, and 5 cover the actual focus controls on the camera and lens and the best situations for their use—from autofocus modes to autofocus points to the autofocus area modes.

Chapter 6 covers situations when the autofocus doesn't work properly and what you can do about them.

Chapter 7 discusses the best times to turn off the autofocus and go with manual focus, such as for fireworks and macro photography. You'll learn about the diopter adjustment to ensure that when you focus the camera you're seeing a sharp image, as well as the lens distance scale and what to look for in the viewfinder to see if the camera thinks the image is in focus.

Chapter 8 is where it all comes together. Here, you'll find the techniques that will result in the sharpest images in a variety of situations. You'll find tips on photographing landscapes, long exposures, sports and action, low-light images, and portraits, as well as macro photography.

Finally, Chapter 9 covers focusing in video. All the new DSLRs not only take great photos, they also shoot great video. With the tips in this chapter, your moving images will be as in focus as your stills.

Q: What are the assignments?

A: There are assignments at the end of each chapter, but don't let that intimidate you. These assignments are a way to practice the techniques and information presented in each chapter. There are no grades, no judging, and no deadlines.

The best way for me to get a handle on new information or new techniques is to go out and try them. That is what the assignments are: a way to practice and try new things before you really need them.

Q: Is there anything else I should know before getting started?

A: As an added value for you, I have provided a few bonus items to help you along the way, including some ideas and inspiration on the creative use of focus and a video of some of Chapter 9's techniques in action.

To access and download the bonus content:

1. Visit peachpit.com/register.
2. Log in with your Peachpit account, or if you don't have one, create an account.
3. Register using the book's ISBN, 9780134304427. This title will then appear in the Registered Products area of your account, and you can click the Access Bonus Content link to be taken to the page where the PDF is available for easy download.

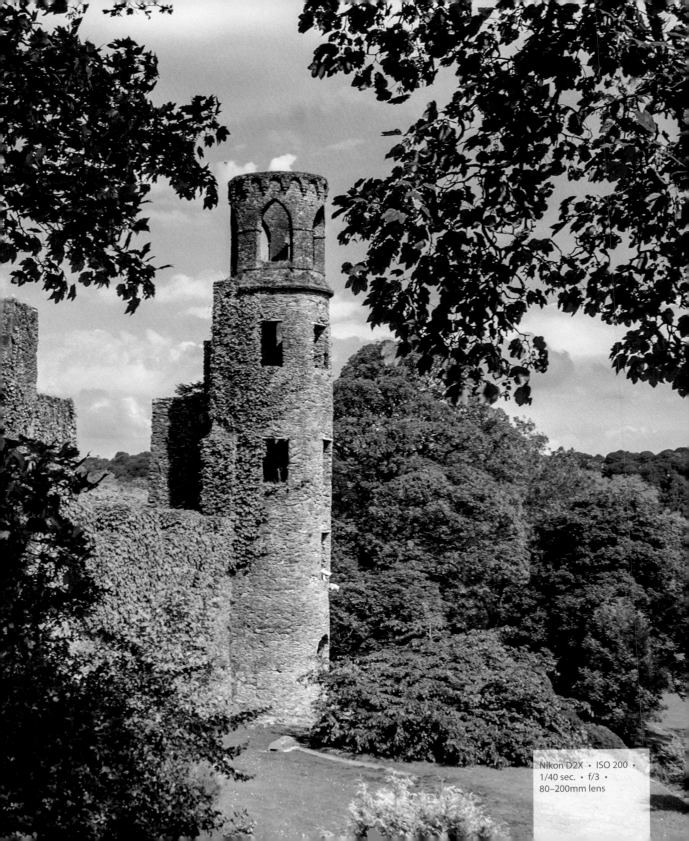

Nikon D2X · ISO 200 ·
1/40 sec. · f/3 ·
80–200mm lens

1

Ten Things to Know About Focus and Autofocus

Quick tips to get you started

Your photos need to be in focus, and more importantly, the main subjects of your images need to be in sharp focus. This chapter is a quick overview of some of the main focus issues to consider when taking photos. I put this chapter right here at the front of the book as a great place to start getting acquainted with focus and autofocus in general.

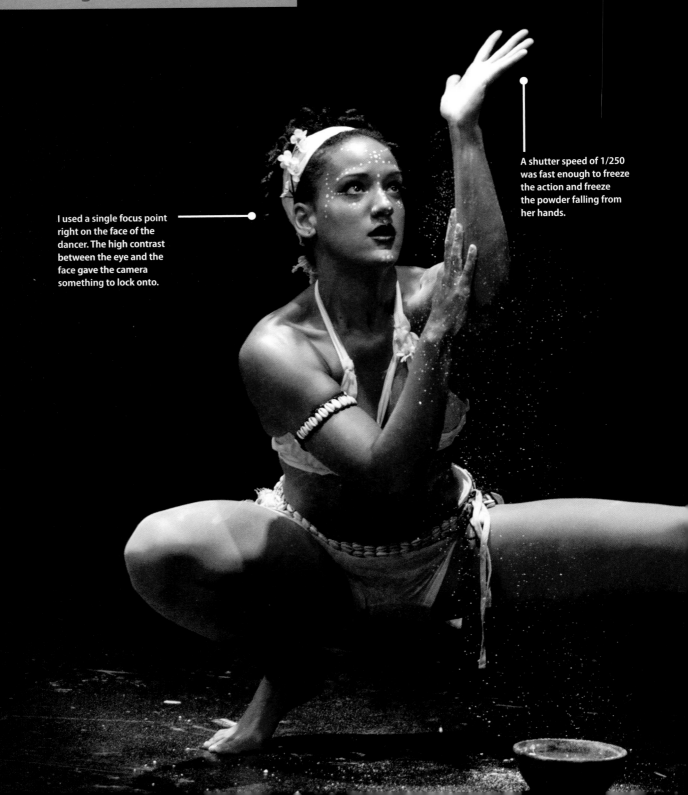

A shutter speed of 1/250 was fast enough to freeze the action and freeze the powder falling from her hands.

I used a single focus point right on the face of the dancer. The high contrast between the eye and the face gave the camera something to lock onto.

This photo was shot during a performance. I needed to make sure that the camera focus stayed right on the dancer, so I used continuous autofocus with a single focus point right on the eye.

I used continuous auto-focus because the dancer was a moving subject.

Nikon D4 · ISO 3200 · 1/250 sec. · f/2.8 · 70–200mm f/2.8 lens

1. Consider the Subject

The first thing to consider when picking the focus mode, or even the focus point, is to decide what the actual focus of the photo is. As the photographer, your job is to lead viewers into your image and make them see what you want them to. Because our eyes are drawn to the areas that are in focus, it is important to make sure that the subject of the photo is in sharp focus and that other elements are not competing with the main subject.

Once you know what the subject is, you can then pick the right focus mode to make sure that the image comes out the way you want. To make your focus settings easier, here are some questions to ask:

- Is the subject moving or staying still? The musician in **Figure 1.1** is moving around, but the boots in **Figure 1.2** aren't going anywhere by themselves.
- Is the subject in bright light or low light?
- Does the subject have enough contrast for the camera to lock focus?

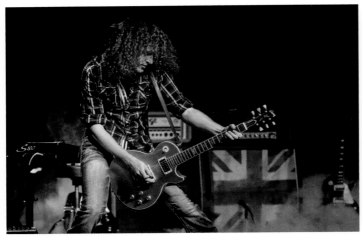

Figure 1.1
When photographing musicians, I want to keep the focus right on them as they move around the stage. For this, I need a fast shutter speed and a shallow depth of field. Above all, I need to keep a focus point right on the subject.

Nikon D4 · ISO 800 · 1/3200 sec. · f/2.8 · 70–200mm lens

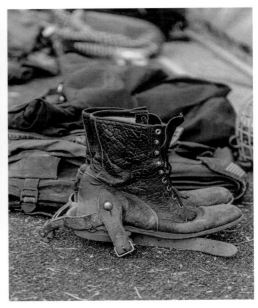

Figure 1.2
For this photo, I wanted the bull-rider's boots to be the subject, so I made sure that the focus was right on the boot and used a wide aperture to blur the background.

Nikon D750 · ISO 1600 · 1/640 sec. · f/2.8 · 70–200mm lens

- Are there elements between the subject and the camera that the autofocus might lock onto?

- What are the current focus settings on the camera and lens? In Figure 1.2, I used a wide aperture to get the background out of focus.

- What other exposure settings might need adjustment to get a sharp image?

There is more to getting a sharp, in-focus image than just picking the right focus mode. You also need to make sure that the shutter speed is fast enough to freeze the motion and that the depth of field is great enough to get all the parts of the image into focus. Chapter 2 covers the relationship between the focus and these settings in detail.

2. Use Manual Focus when Needed

Modern cameras and lenses give you amazing autofocus capabilities, but there are still times when you will want to use manual focus. When you have your camera and lens set to autofocus, the camera uses a motor in either the camera body or the lens to adjust the focus automatically, usually as you press the shutter release button down to take the photo. With manual focus, you have to turn the lens barrel to focus the photo, and the camera does nothing.

When you will want to manually focus instead of letting the camera focus for you? Here are a few examples:

- **Photographing Fireworks.** If you use autofocus to try to capture fireworks, the camera will try to refocus as the shells explode, and by the time the autofocus locks on, you have missed most of the shot. The key is to use the autofocus on the first firework as it goes up, then before the next photo, with the camera still focused on the spot where the first firework exploded, switch over to manual focus. The camera won't try to focus again on every shot, and the rest of the photos will be in focus because firework displays all aim the rockets for the same spot so the crowd knows where to look. That way you can start taking the exposure as the rocket soars skyward before it explodes. You can see an example of this in **Figure 1.3**; I set the camera to manual focus so that it captured both the rocket's flight and the explosion in the frame.

- **Extreme Low Light.** For the autofocus to work properly, the autofocus module in the camera needs to see the scene in front of the camera so it can determine which way to adjust the focus. When you are shooting in really low light, the autofocus can have issues "seeing," so manual focus is usually a better option.

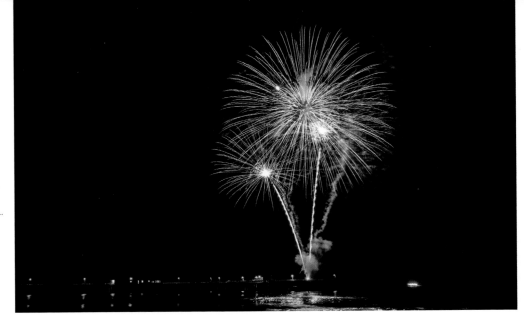

Figure 1.3
The focus was set to the spot where the first firework exploded so that the rest of the fireworks would be in focus. This burst was captured with the camera set to manual focus.

Nikon D4 • ISO 400 • 5.5 sec. • f/10.0 • 24–70mm lens

- **Low-Contrast Scenes.** The autofocus module in the camera needs to be able to determine if something in the scene is in focus by looking at the contrast between different items. If the scene has very little contrast, then the camera has very little to work with and the autofocus will not work well. This is a good time to switch to manual focus.

- **Macro Photography.** When you photograph with a macro lens, the depth of field can be extremely shallow, especially when you're very close to the subject. It is even more critical to make sure that your focus is exactly where you want it to avoid blurring your subject, so manual focus is a better choice. For **Figure 1.4**, I manually set the focus so that the focus point would be right on the middle of the flower.

Figure 1.4
For this macro photo of a white orchid, I used manual focus to make sure that the middle part of the flower was sharp. The autofocus would have had issues with all the white areas because they lack anything with contrast for the focus to lock onto.

Nikon D4 • ISO 400 • 1/100 sec. • f/7.1 • 105 mm Macro lens

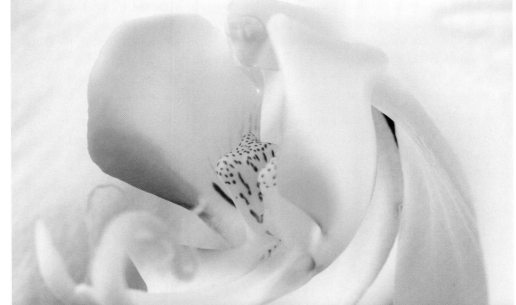

- **Time-Lapse Photography.** With time-lapse photography, you take a series of photos over time and put them together into a movie. The best way to do this is to keep the camera steady on a tripod and the focus locked so that the final movie looks smooth. You don't want the focus to keep shifting every frame, so set the camera to manual focus so that anything moving in the frame during the photo doesn't cause the autofocus to engage.

3. Focus Controls on the Camera

Your camera has a set of controls that determine which focus mode and which of the focus points will be used. Make sure you know where these controls are and what they do. With practice, you should be able to adjust the focus mode and change the number of focus points, as well as which ones are being used, without taking your eye away from the viewfinder.

Each camera manufacturer puts the focus controls in different places and the controls can actually vary from model to model. There are three key controls that you need to be aware of:

- The first changes the focus mode between autofocus and manual focus.

- The second switches between the various autofocus modes.

- The third allows you to select which focus points to use.

In **Figures 1.5** through **1.7**, you can see the focus controls on the Nikon D750, the Canon 5D Mark III, and the Sony A7II, respectively. For the specific controls on your camera, check the camera manual.

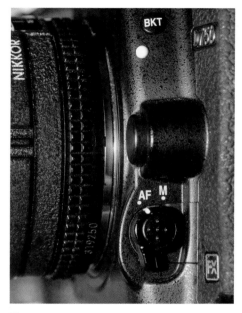

Figure 1.5
On the Nikon D750, you use this lever to switch between AF (autofocus) and M (manual).

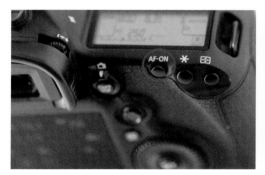

Figure 1.6
The Canon 5D Mark III allows you to activate the Autofocus with the AF-ON button.

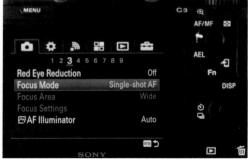

Figure 1.7
The focus controls on the Sony A7II are mainly in the menu system with a full Autofocus menu.

4. Focus Controls on the Lens

Many lenses, especially the more expensive higher-end lenses, have focus controls right on the lens. These controls can override the controls on the camera and cause headaches if you don't know what they are doing. To make it more interesting, or at least more frustrating, not all lenses have all three focus controls, and some don't have any focus controls at all.

The most important thing to look for is whether the lens has a switch or button that turns autofocus on or off. **Figure 1.8** shows the switch on a Nikon lens, for example, while **Figure 1.9** shows one on a Canon lens. But the on-lens controls can also be more complicated, giving you a choice that might not make much sense, like the three options shown in **Figure 1.10**: A/M, M/A, and M. These take a little more explaining, as they control how the focusing motor in the lens works when autofocusing. The first two settings, A/M and M/A, are both autofocus settings in which the autofocus can be overridden by the photographer turning the focusing ring on the lens. The sensitivity of the focus ring is greatly reduced in the A/M mode, however.

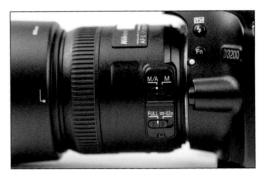

Figure 1.8
This switch on the AF-S Micro Nikkor 40mm turns the autofocus on and off. M/A is the Manual/Autofocus setting, which allows the lens to be autofocused and manually focused. The M setting is for manual focus, which disengages the autofocus motor and allows only manual focus using the focus ring on the lens.

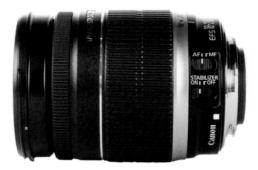

Figure 1.9
You can see the switch on the side of the Canon 18–200mm lens that allows you to switch between AF (autofocus) and MF (manual focus). (Photo by Jerod Foster.)

Figure 1.10
The focus switch on the Nikon 400mm f/28 lens offers three options: A/M, M/A, and M. The first two are both autofocus modes, while the third is the manual focus mode.

The last thing to know about the focus modes controlled by the lens is that for the camera to use autofocus, both the focus mode on the camera and the focus mode on the lens need to be set to Autofocus. If one of these controls is set to Manual mode, then the camera will not autofocus.

5. The Right Autofocus Mode for the Subject

There are three basic focus modes: manual focus, continuous autofocus, and single-subject autofocus. Each of these modes can help you get the sharpest images possible as long as they are used with the right subject.

Continuous autofocus is best used for moving subjects, as the camera continues to focus until the moment the shutter is finally released and the photo is taken. I used continuous autofocus to take the photo of the surfer in **Figure 1.11**.

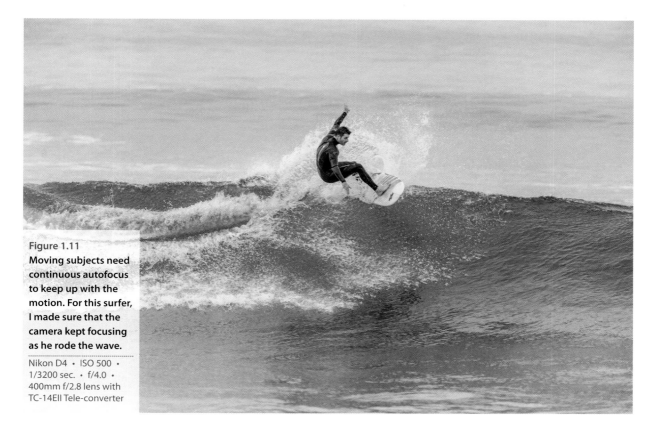

Figure 1.11
Moving subjects need continuous autofocus to keep up with the motion. For this surfer, I made sure that the camera kept focusing as he rode the wave.

Nikon D4 • ISO 500 • 1/3200 sec. • f/4.0 • 400mm f/2.8 lens with TC-14EII Tele-converter

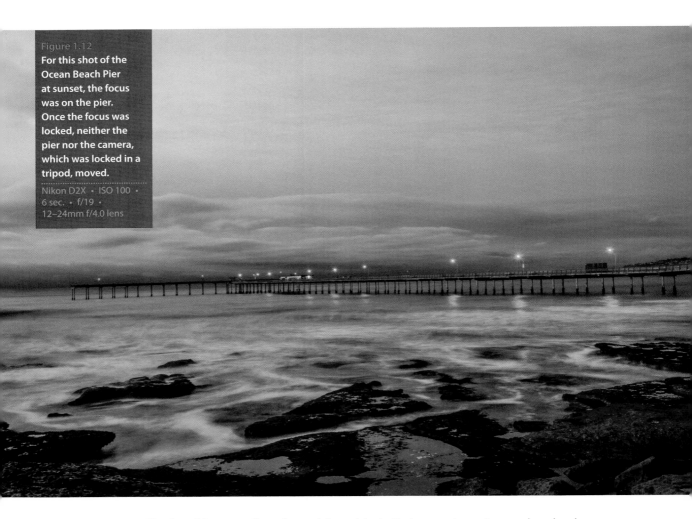

Figure 1.12

For this shot of the Ocean Beach Pier at sunset, the focus was on the pier. Once the focus was locked, neither the pier nor the camera, which was locked in a tripod, moved.

Nikon D2X • ISO 100 • 6 sec. • f/19 • 12–24mm f/4.0 lens

Single-subject autofocus is used for subjects that are not moving, such as landscapes or still-life photographs. In this mode, the autofocus engages when the shutter release button is pressed halfway down (or the back-button focus is pressed) until the camera achieves focus, then the focus is locked until the photo is taken. If the camera or subject moves after the focus is locked, the camera will not refocus and the image can be blurry. The scene in **Figure 1.12** was taken using the single-subject autofocus; the camera was on a tripod and the pier wasn't going to move.

Many cameras have a third autofocus mode that tries to be the best of all worlds. Called *automatic autofocus*, this autofocus mode tries to determine if the subject is moving or still and then either works like single-subject or continuous autofocus.

6. Pick the Autofocus Area/Autofocus Point

Digital single-lens cameras (DSLRs) have multiple focus points that you can use to tell the camera where to focus. These points are usually referred to as the *autofocus area* depending on the number of points used. Some cameras have 50 or

more of these focus points, but others might have only 9 or 11. These focus points are seen through the viewfinder as small squares usually clustered in the middle of the frame. The good news is that you can not only tell the camera how many of the focus points to use, you can also tell the camera which ones to use. In **Figure 1.13**, you can see the focus point layout of the Nikon D750 with a single, selected point in red.

The Nikon system has three autofocus area modes: Single Point Autofocus, Dynamic Area Autofocus, and Auto Area Autofocus.

- **Single Point.** In this mode, the camera just uses a single autofocus point.

- **Dynamic.** In this mode, the camera uses multiple points to try to keep track of the moving subject.

- **Auto Area.** In this mode, the camera automatically tries to figure out the subject and tries to keep it in focus.

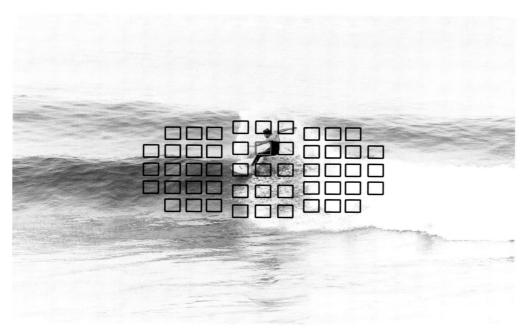

Figure 1.13
Through the viewfinder of the Nikon D750 you can see the selected point amidst all the camera's focus points. Notice that the single active point (in red) is right on the surfer.

With the Canon system you can also divide the autofocus areas into three modes:

- **Single Point/Spot.** In this mode, the camera uses a single point (or an even smaller spot area).
- **Point Expansion/Zone.** In these modes, the camera uses a larger selection of focus points.
- **Automatic Point.** This mode lets the camera pick the focus point.

Chapter 5 will cover how to select the different autofocus areas and the number of focus points, but for now you will just want to be able to move through the single focus points and select one to use. A control on the back of the camera enables you to cycle through the focus points and choose one.

The controls differ on each camera. For example, the Nikon D750 has 51 focus points, and you use the thumb rocker switch to move left, right, up, and down to select the desired focus point. The Canon EOS 7D Mark II has 65 focus points (**Figure 1.14**) that you can select individually or in groups. On the Sony Alpha 7R II, you get a whopping 399 phase-detection points and 25 contrast-detection points. (You'll more about these point types in Chapter 2.) This camera has multiple focus areas, from a flexible spot to using all 399 points. Check your camera manual for exactly how to move the focus points on your camera model.

Figure 1.14
Here is the layout of the focus points in the Canon EOS 7D Mark II, as seen through the viewfinder, with the focus right on the eye of the cat.

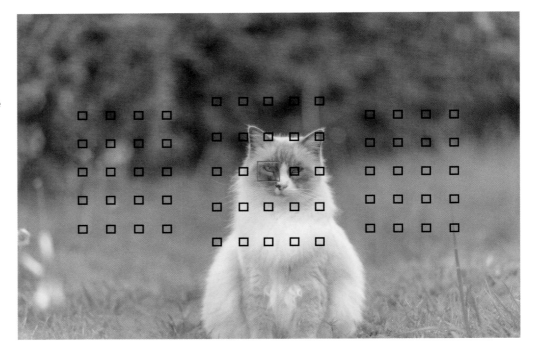

7. Use Pre-Focus

In the default mode of most cameras, the autofocus system of the camera is engaged when the shutter release button is pressed halfway down. This allows you to engage the focus before actually taking the photo and can really help when it comes to photographing moving subjects.

The term "pre-focus" is used to describe the technique that many professionals use to get to great action shots. When you know where the action is going to take place, you can focus the camera to that spot before the subject is there, then wait until the action comes to that spot to take the photo. For example, I knew that the dogs running the agility course were going to be jumping over the bar, so for **Figure 1.15**, I pre-focused on the bar and just waited for the dog to jump. This technique works well but is not perfect. It takes some practice, timing, and good luck.

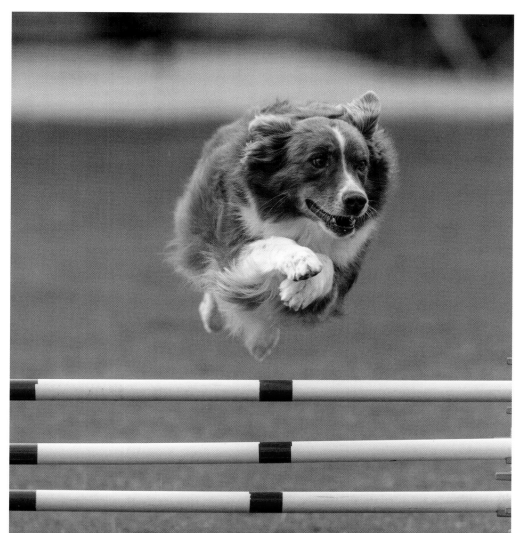

Figure 1.15
It was very difficult to focus on the dogs as they ran around the agility course, so I focused on a spot where I knew the dogs would be jumping. Then it was just a matter of timing to capture the dogs in mid-jump.

Nikon D4 · ISO 800 · 1/4000 sec · f/4 · 400mm f/2.8 lens

8. Back-Button Autofocus

The default setting of most DSLR cameras is for the focus to engage when the shutter release button is pressed halfway down. This means that the camera focuses, or tries to focus, as you take every photo. There is another option on many cameras that allows you to assign a different button to control the focus, leaving the shutter release button to control only the shutter. This allows you to keep the focus on something and not have the camera try to focus each time you take a photo. You get to decide when to engage the autofocus. This is not really important if you are photographing a static scene where nothing is going to change in front of the camera, but it is really useful when photographing sports or any activity where people or items can momentarily come between you and the subject.

For example, most sports photographers use back-button autofocus so that while they are photographing a player on the field with their finger holding the shutter release button, the camera doesn't try to focus on another player or referee who momentarily gets in the way. Instead, they must specifically release the alternate button they are using to activate the focus, and then they can continue to take photos using the shutter release button. I used back-button focus when shooting the Poinsettia Bowl so that I could make sure that the players stayed in focus and the officials didn't pull the focus, even when they walked into the frame and momentarily in front of the player I was photographing, while I was pressing down on the shutter release button (**Figure 1.16**).

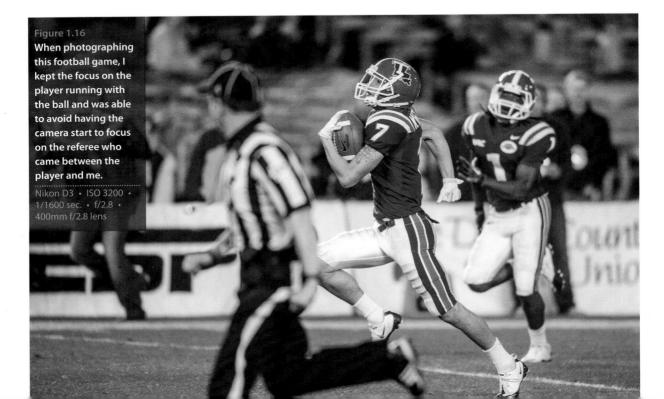

Figure 1.16
When photographing this football game, I kept the focus on the player running with the ball and was able to avoid having the camera start to focus on the referee who came between the player and me.

Nikon D3 • ISO 3200 • 1/1600 sec. • f/2.8 • 400mm f/2.8 lens

It does take some practice getting used to the focus and the shutter release not being tied to the same button, but it can be a real advantage in shooting situations where something can momentarily get between you and the main subject. On the Nikon D750, you can set the AE-L/AF-L button to act as a focus button, as shown in the f4 menu in **Figure 1.17**.

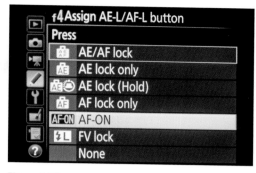

Figure 1.17
The f4 Custom menu shows that the AE-L/AF-L button is set to AF-ON.

9. Test Your Camera's Focus

One of the most frustrating experiences a photographer can have is when you just *know* you got the shot only to find out when you see it later on the big computer screen that the focus is off. Instead of a tack-sharp image, you have just enough blur to take the image from fantastic to trash. Sometimes this is due to focusing on the wrong spot in the image or using the wrong focus mode, but it could also be that the focus of the lens and camera are not perfect.

With many of today's cameras, you can test the lenses and make micro adjustments without having to send the camera and lenses back to the manufacturer. The first thing you have to do is test the camera and lens to see if it is an error with the hardware or with the photographer. To test the focus, you can buy a lens align tool or you can just make your own.

To do it yourself, you will need a tripod, a measuring tape, an evenly lit area, and a spot to focus on. I use a sheet of poster board and a small piece of black electrical tape (**Figure 1.18**). You need to place the camera and lens on the tripod at the distance you use the lens at most often. For me, that is about 12 feet with a 70mm lens. The key to this method is to place the tape measure in the middle of the focus area, then make sure the focus is right on the center part of the tape. Use the widest aperture on the lens creating the shallowest depth of field. Take the photo, and then look at what is in focus on the tape measure. If the numbers in front of the tape are more in focus, that's called *front focus*. If the numbers behind the tape are in focus, that's called *back focus*. What you want is for the numbers right at the tape mark to be in focus.

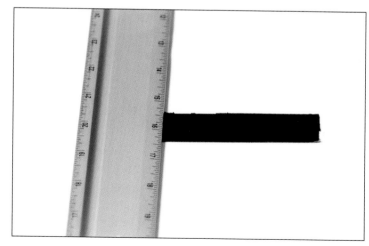

Figure 1.18
The tape and ruler show the camera and lens are in focus.

A second way to test the autofocus is to compare the results using the two different focus technologies in your camera. When you look through the viewfinder of your camera and focus using one or more of the focus points, the camera is using the autofocus module and technology called *phase detection*. If your camera shoots video and has a Live View capability, then there is a second type of autofocus technology used called *contrast detection* (**Figure 1.19**). Both of these technologies are covered in more detail in Chapter 2, but here we are going to use them to make sure that the focus in your camera is working properly. The idea is to focus and take photos using the Live View mode, which uses the contrast-detection focus, and then comparing its results to those using the phase-detection autofocus.

Just follow these steps:

1. Put the camera in a tripod pointed at a blank wall.

2. Place a focus chart on the wall and make sure the camera and chart are in line and about 7 to 12 feet apart.

3. Set the camera to Manual mode, and open the aperture as wide as possible. Adjust the shutter speed to get a proper exposure.

4. Turn on Live View mode, and use the center focus point to focus on the center of the focus chart.

5. Take a series of photos, making sure the focus is right on the center of the focus chart.

6. Turn Live View mode off, focus through the viewfinder, and take a second series of photos.

7. Compare the photos to see if the focus is off.

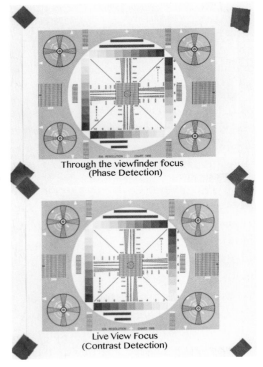

Through the viewfinder focus
(Phase Detection)

Live View Focus
(Contrast Detection)

Figure 1.19

Here you can see the two photos showing the focus is the same using Live View and the regular view through the viewfinder focus.

If the focus is off on your camera and lens, the best bet is to send it in for a service and cleaning by the camera manufacturer. Make sure you explain that the focus is off and that it needs adjustment. Some cameras do allow you to adjust the focus yourself using the micro-focus adjustments. Check your camera manual for the micro-adjustment capability of your model. Chapter 6 will cover lens adjustments in more detail.

10. Autofocus Issues and Solutions

Autofocus is really good and getting better with each new camera, but there are still certain situations where the autofocus doesn't do what you want it to.

- **Autofocus tends to focus on what is closest to the camera.** The camera assumes that the object closest to the camera is the subject of your image and tries to focus on that, especially when you use the auto area settings. The reality is that sometimes your subject is not the closest thing to camera, and autofocus is trying to focus on the wrong thing. The easiest way to change this is to change the autofocus area to a single point or a small group and then make sure the focus point is on the subject.

- **Autofocus can have a hard time in low light.** The camera needs to see the subject so that it can focus. When shooting very dark scenes, sometimes there is not enough light to achieve focus, so many cameras have a built-in lamp that lights up the scene. This lamp acts like a small flashlight letting the camera autofocus see the scene. This lamp can be very distracting in some circumstances, so know how to turn it off if needed. For **Figure 1.20**, I needed a flashlight to illuminate the model due to the lack of ambient light.

- **Autofocus can have difficulties when shooting through glass.** The light coming through the glass can make the camera's autofocus miss the subject, especially if the subject is moving. The best way to work around this is to get the glass as close to the front of the lens as possible. The shorter distance makes it easier for the focus to lock on.

- **The autofocus system needs contrast.** The camera autofocus system is based on contrast, so the subject needs to have contrast for the autofocus to work. When a scene has very low contrast, the autofocus will hunt, trying to find something to lock onto. The solution to this issue is to find something else to focus on that is in line with the subject you want in focus. For example, in **Figure 1.21**, I made sure the focus point was on the face and beak of the bird and not on the low-contrast body area.

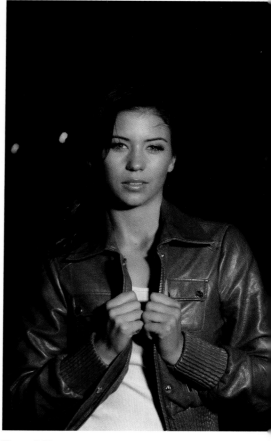

Figure 1.20

This photo was taken in nearly complete darkness. I had to use a flashlight on the model so that the camera could focus right before the photo was taken.

Nikon D700 · ISO 200 · 1/4 sec. · f/4.0 · 24–70mm f/2.8 lens

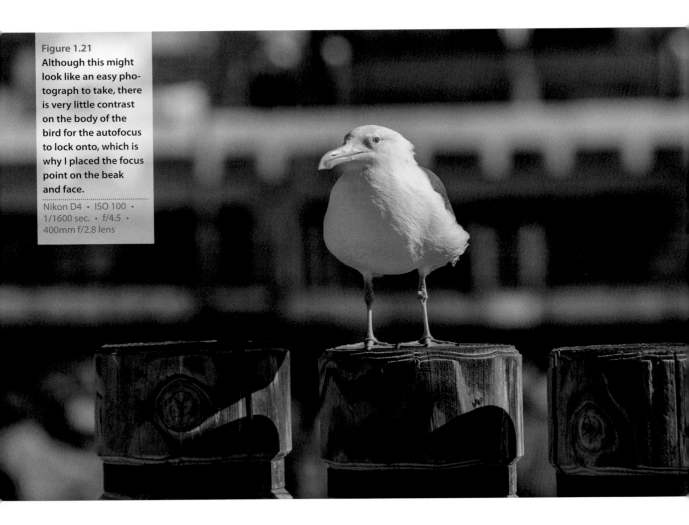

Figure 1.21
Although this might look like an easy photograph to take, there is very little contrast on the body of the bird for the autofocus to lock onto, which is why I placed the focus point on the beak and face.

Nikon D4 · ISO 100 · 1/1600 sec. · f/4.5 · 400mm f/2.8 lens

Chapter 1 Assignments

Change Between Manual and Autofocus

Mastering control of focus means that you need to master the focus controls of your camera. The first part of that is to be able to switch from autofocus to manual focus. Go ahead and autofocus on a stationary subject, then switch to manual focus and adjust the focus and camera position.

Try Back-Button Autofocus

Check your camera manual to find out how to set back-button autofocus. Pick a moving subject like a running pet or flying bird, and try to use the back-button focus to keep the subject in focus. Practice how to focus and take photos using two different buttons.

Test Your Camera's Focus

Try one of the focus tests discussed in the chapter with your camera and lens. Knowing that your lens is properly focusing makes it easier to troubleshoot other focusing issues.

Share you results with the book's Flickr group!
Join the group here: flickr.com/groups/focusandautofocus_fromsnapshotstogreatshots

Nikon D3 • ISO 400 •
1/2000 sec. • f/4.0 •
70–200mm lens

2
The Basics of Autofocus

How autofocus works and why you should care

You don't need to know how the autofocus in your camera works, but you should. Knowing what the camera is doing as it tries to autofocus allows you to help it along and, in doing so, get the best results. The autofocus in your camera is an amazing technology that photographers just take for granted now. When I started out in photography, there was no autofocus and capturing a sharp photo of a motocross rider in the air would have been nearly impossible without a lot of practice. Now, understanding the different types of autofocus used and what the various autofocus modes are on your camera ensures you get the best results.

Poring Over the Picture

The red collar on the dog was a perfect area to focus on, as it had enough contrast and was close to the head of the dog, which helped keep the eye sharp.

Having the focus on the dog and a shallow depth of field allowed the subject to pop out of the photo.

Nikon D4 • ISO 800 •
1/4000 sec. • f/2.8 •
70–200mm lens

Letting the autofocus keep the subject in focus allowed me to time the shot and catch the dog in mid-stride with all four paws in the air.

Photographing a dog running on the beach is the perfect test of a camera's autofocus, and here it performed perfectly. With the camera taking care of the autofocus, I was able to concentrate on the composition, catching the dog in mid-stride.

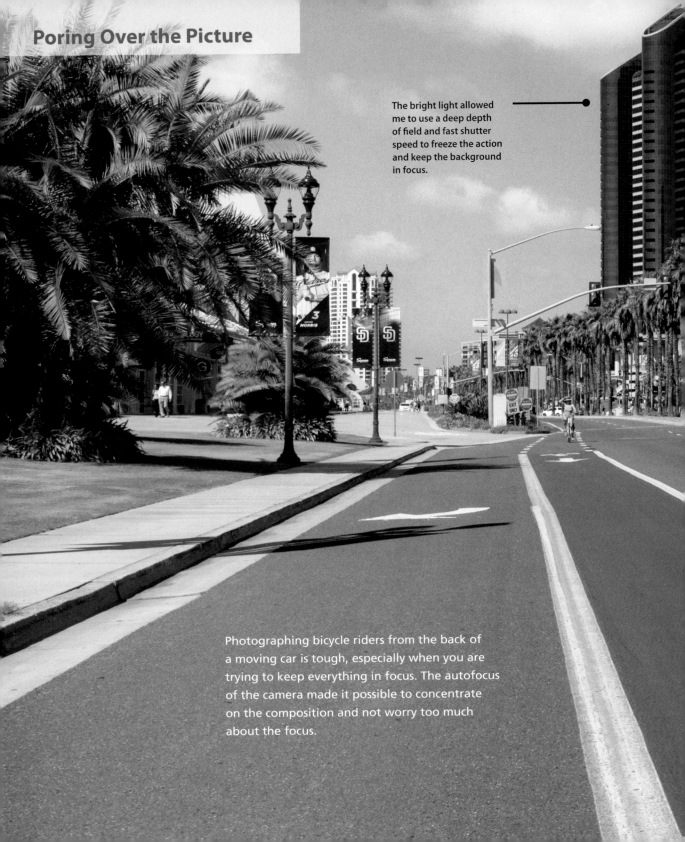

Poring Over the Picture

The bright light allowed me to use a deep depth of field and fast shutter speed to freeze the action and keep the background in focus.

Photographing bicycle riders from the back of a moving car is tough, especially when you are trying to keep everything in focus. The autofocus of the camera made it possible to concentrate on the composition and not worry too much about the focus.

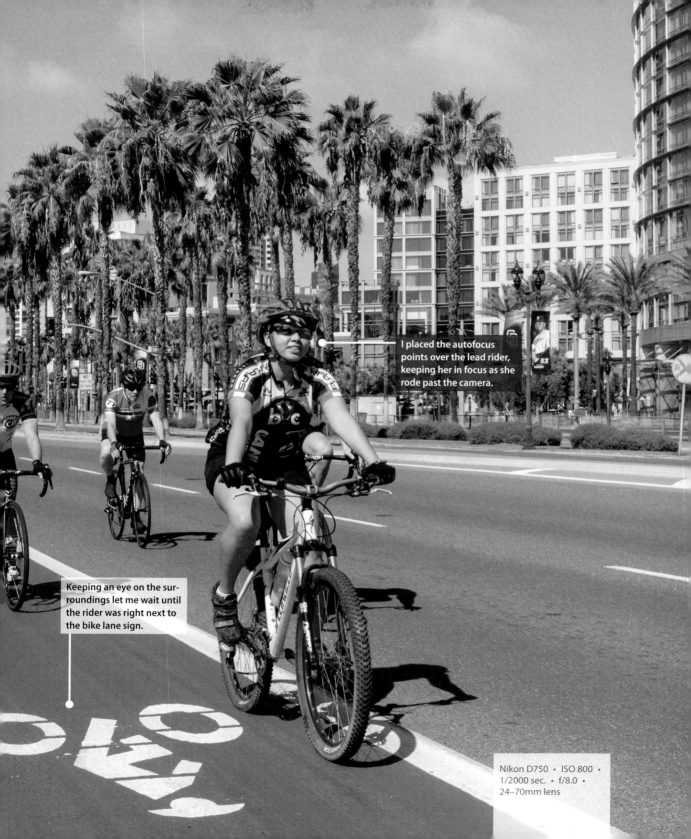

I placed the autofocus points over the lead rider, keeping her in focus as she rode past the camera.

Keeping an eye on the surroundings let me wait until the rider was right next to the bike lane sign.

Nikon D750 • ISO 800 •
1/2000 sec. • f/8.0 •
24–70mm lens

A Short History of Autofocus

We take autofocus for granted, as it is built into every camera available today, including all the smartphone cameras, but autofocus is actually relatively new in the timeline of photography. The first mass-produced camera with autofocus was released in 1977, and that was a small point-and-shoot. Not until 1981 did Pentax release the Pentax ME-F with a focus sensor in the body and a motor in the lens. Nikon released the F3AF in 1983, and eventually in 1985, Minolta released the first camera with the focus system and focusing motor in the camera body. Currently, the Nikon and Canon entry-level camera bodies have great autofocus systems, but for them to work they need to be used with lenses that have a focusing motor built in. The important part to understand is that this technology is rather new. It's not perfect, but it is getting better with each and every new model camera released.

Camera manufacturers have increased the ability of the focus to lock on and track subjects with more accurate autofocus and more autofocus points. Autofocus technology has also evolved in conjunction with the ability of DLSR cameras to record video and the rise in popularity of mirrorless camera bodies. All these technologies are making it easier than ever before to get sharp, in-focus images.

The first camera that I owned with autofocus was the Nikon N6006, and it was liberating to concentrate on the composition and action happening through the viewfinder while letting the camera deal with the focus. The autofocus capability of the camera was a far cry from the abilities of today's cameras, but it still was better than trying to manually focus fast-moving subjects. I upgraded to the Nikon N80 (shown in **Figure 2.1**), which had a five-area autofocus system and was the first camera I used that gave me the option of what to focus on by selecting an autofocus point.

Figure 2.1
The Nikon N80 allowed me to pick between manual focus, single-subject autofocus, and continuous autofocus right on the front of the camera.

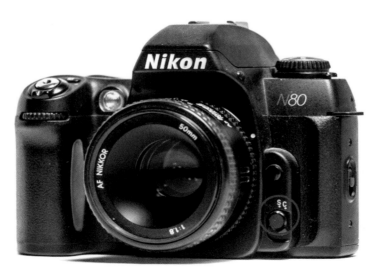

Autofocus Types and How They Work

When you engage the autofocus, your camera tries to focus on the subject in front of it. How the camera does that is a marvel of technology that has greatly improved over the past camera generations. Today, you can choose among multiple technologies to use, matching the autofocus mode to the type of photo you are capturing.

Active versus Passive Autofocus

Autofocus technology can be broadly divided into two types: active and passive.

With *active autofocus*, the camera (or external flash) emits a signal that measures the distance to the subject and adjusts the focus to match the distance. Active autofocus needs a way to measure the distance from the camera to the subject. This method needs more hardware and can cost more. It also has a limited range, because the active component needs to send the signal out and wait for its return. As a result, it works well for subjects a few feet away but doesn't work for items far in the distance, such as a bird in flight, for example.

With *passive autofocus*, sensors in the camera look at the contrast in the image being projected onto the mirror and adjust the focus. Passive autofocus technology can be further divided into two different forms: phase detection and contrast detection. The names can be a little misleading. Both techniques use contrast in determining when the subject is in focus, but they use it in very different ways.

Phase Detection

In very simple terms, *phase-detection autofocus* works by very quickly comparing two images of the same subject and then checking to see if they are the same. If the two images are identical, the photo is in focus. If they are not the same, the camera takes the image information and sends a command to the focusing motor, which adjusts the focus, and then checks two new images to see if they match up. Because the camera is comparing two versions of the scene, there is a lot of information that it can use to adjust the focus quickly. The phase detection can tell if the lens is focused too near, too far, or just right, making it possible to adjust the focus in the correct direction right away.

Phase-detection autofocus is controlled by a module that lives in the camera and uses information coming through the lens. The autofocus module, shown in **Figure 2.2**, is located below the main mirror, and a second mirror bounces the light down to it. When you look through the viewfinder, you see the light that is reflected off the subject coming in through the lens. Most of that light is reflected up to the pentaprism viewfinder, allowing you to see the image the right way up, but some of the light passes through the main

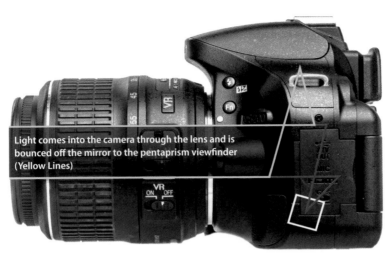

Figure 2.2
The autofocus module is located at the bottom of the camera body, where the light reflected down by the sub-mirror can be read and measured.

Light comes into the camera through the lens and is bounced off the mirror to the pentaprism viewfinder (Yellow Lines)

The same light is also bounced down to the AF module (Red Lines)

mirror and is reflected down to the autofocus module. The module then directs the light to the sensors (you need two for each focus point), and the autofocus module compares the information from the sensors. If the information is identical, then the subject in front of the selected autofocus point is in focus; if the information is different, then the camera sends a signal to adjust the lens.

This system works well if everything is properly set and all the distances and angles are properly calibrated. The focusing system is a separate module from the image sensor, so when you take photos, the mirror is moved out of the way and the camera can no longer adjust the focus because no information reaches the autofocus module. This means that the distance between the autofocus module and the lens mount and the distance between the sensor and the lens mount need to be exactly the same or the difference in distance needs to be calculated exactly. If it is off by even a tiny amount, the focus will be off.

The main advantage to phase-detection autofocus is speed. Because of the way phase detection works, the camera knows which way to adjust the lens, which makes the focusing process faster than that of contrast-detection autofocus. This probably doesn't matter a lot when you are shooting a stationary subject, but it helps immensely when shooting moving subjects like the musicians in **Figure 2.3**. As they moved back and forth, the autofocus kept up with their every move.

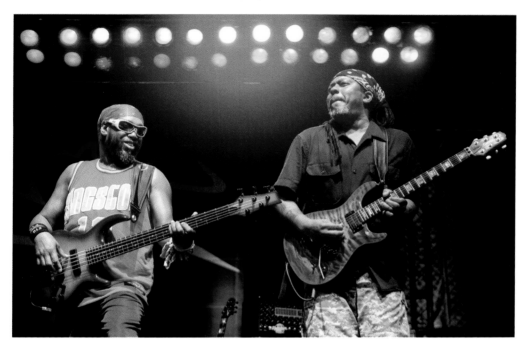

Figure 2.3
Photographing concerts is a lot easier when the autofocus can keep up with the movement of the musicians.
......................................
Nikon D750 •
ISO 3200 •
1/320 sec. • f/2.8 •
24–70mm lens

Contrast Detection

When the camera is set to Live View mode, the mirror is moved up and out of the way and the image coming through the lens is no longer reflected up to the viewfinder. With the mirror out of the way, the image is also no longer reflected down to the phase-detection autofocus sensors. This means that the camera needs a second type of autofocus technology, a contrast-detection autofocus engine.

In *contrast detection*, the camera looks at the selected focus points and checks the contrast, then it adjusts the focus and checks the contrast again. It is a basic trial-and-error method that is much slower than the phase-detection method.

The real advantage to the contrast-detection method over the phase-detection method is it can be used at any point on the sensor, whereas the phase-detection autofocus is limited to the middle area of the frame, as illustrated in **Figure 2.4**.

Figure 2.4
The LCD screen on the back of the D750 in Live View mode shows the focus point at the bottom of the frame, outside of the area that the phase-detection autofocuses.

The Names Used in Autofocus

Each of the camera manufacturers uses different names for its autofocus functions. This can be confusing, because although the names are different, the functions are all very similar. The following is the full list of terms used by the three major camera brands: Nikon, Canon, and Sony.

Nikon

The following is the nomenclature that the Nikon camera system uses. There are two sets of autofocus modes and autofocus areas. You'll use the first when using the viewfinder, meaning the mirror is in place so that the camera can use phase-detection focus. The second is for the Live View mode and video, when the mirror is locked up and the camera needs to switch to a contrast-detection mode.

Nikon Viewfinder Focus Modes

When using the viewfinder, you have four choices of focus mode:

- **MF (Manual Focus).** In manual focus, the camera does not control the focus at all. To focus the camera, you need to turn the focus ring on the lens.

- **AF-C (Continuous Servo Autofocus).** In AF-C, the camera will keep focusing as long as you continue to hold the shutter release button halfway down. In this mode, you can use all the autofocus area modes listed in the next section.

- **AF-S (Single Servo Autofocus).** In this mode, the camera will lock on focus when the shutter release button is pressed halfway down. If the subject or camera moves, the focus will not change unless you release the shutter release button and then press it down halfway again. This mode is limited in which autofocus areas it can use. It can use the Single Point AF, the Group AF, and the Auto AF.

- **AF-A (Auto Autofocus).** This mode tries to be both the AF-S and AF-C by determining if the subject is staying still or moving. This mode can use all the autofocus area modes listed in the next section.

Nikon Viewfinder Autofocus Area Modes

There are four autofocus area modes. Which you have depends on the Nikon DSLR model:

- **Single Point AF.** In this mode, the camera uses a single autofocus point, making sure that the most important item in the frame is in focus.

- **Dynamic Area AF.** In this mode, you still pick a single focus point, but the camera then uses the focus points around it to help track and keep focus on the subject. If the

subject moves from the selected focus point, then the camera will use the information from the surrounding points to keep the subject in focus. This is great for photographing subjects that are moving erratically. You get to pick from *9, 11, 21, 39,* or *51 points*.

Not all cameras have all the points, and you should check with the camera manual for the options for your camera model. There is also a *Group mode* available only on newer cameras from Nikon, and instead of using a single point and tracking the movement around using surrounding points, it links up five points and uses them all to keep track of the subject as it moves. You see four of the points highlighted, but there is a fifth in the middle. In this mode, the group of autofocus points acts as a large single point and all five points work to achieve focus. You can see the group of focus points in **Figure 2.5**.

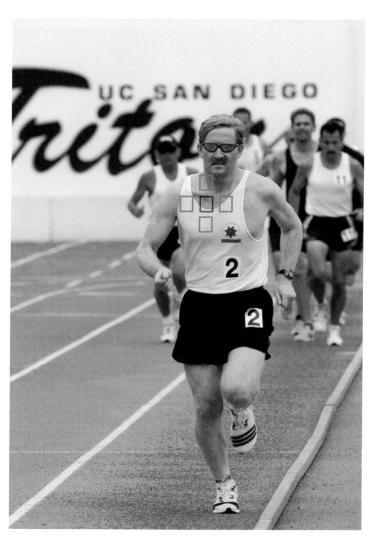

- **3D Area AF.** The 3D tracking takes over control of the selected focus point and tries to keep it on the moving subject. Although this mode works well, especially with a subject that is moving against a relatively plain background, like a bird in flight, the actual focus point can jump around quite a bit because the camera chooses where to focus.

- **Auto Area AF.** In this mode, the camera is in charge and picks the focus point. This method uses facial recognition and color information to try to keep the focus on a face, if one is present, and on the closest face if there is more than one. This works great for faces, but not so well for other subjects. This is not a mode I recommend or a mode I use.

Figure 2.5
The Group AF mode uses 5 autofocus points as one large point, which helps when photographing subjects like this runner. The group is comprised of the five focus points shown, but through the viewfinder you would not see the one shown in gray.

Nikon D750 • ISO 800 • 1/2000 sec. • f/4.0 • 300mm lens

Nikon Live View Focus Modes

There are three focus modes in the Live View and video mode:

- **M (Manual Focus).** In this mode, you need to focus using the focus ring on the lens.

- **AF-S (Single-Servo AF).** In this mode, the focus is engaged when you press the shutter release button halfway down. Once the camera achieves focus, it doesn't change unless you release the shutter release button and then press it down halfway again.

- **AF-F (Full-Time Servo).** In this mode, the camera keeps trying to focus on the subject even if the subject or camera moves. When shooting video, the camera will keep trying to autofocus on the subject while recording.

Nikon Live View Focus Areas

The Live View modes cannot use the phase-detection autofocus engine, but instead use the contrast-detection technology built into the sensor:

- **Wide Area AF.** This is used for landscapes and larger subjects. The focus point can be moved anywhere in the frame.

- **Normal Area AF.** This setting uses a smaller area to check the autofocus and gives you more control over what is in focus. The focus point can be used anywhere in the frame.

- **Subject Tracking AF.** In this mode, you set the focus point on the subject that you want to focus on, and then you turn the focus on and the camera tries to keep the subject in focus. This works quite well as long as the subject isn't moving too fast or gets hidden as it moves across the frame.

- **Face Priority AF.** This autofocus mode works by looking for facial features and keeping the focus on the face of the subject. If the camera detects multiple faces, it will focus on the one closest to the camera.

Canon

The following are the names that the Canon brand of cameras and lenses uses to describe the focus and autofocus modes and areas, as well as the Live View modes and areas.

Canon Viewfinder Focus Modes

When using the viewfinder, you have four choices of focus mode:

- **Manual Focus.** In this mode, you need to focus by turning the focus ring on the lens.

- **AI Servo AF.** This is the Canon term for continuous autofocus, where the camera keeps focusing while the shutter release button is pressed halfway down.

- **One-Shot AF.** In this mode, the camera focuses on the subject when you press the shutter release button halfway down. Once the focus is achieved, the camera stops adjusting the focus even if the camera or subject moves.

- **AI Focus AF.** This is the automatic focus mode that switches between the AI Servo AF and the One-Shot AF, depending on what the camera thinks is going on.

Canon Viewfinder Focus Areas

The following are the focus areas available on the Canon camera system when using the viewfinder focus modes.

- **Single Point AF.** This mode allows you to pick a single focus point and the camera will ignore the rest. In **Figure 2.6**, you can see Single Point AF mode in use.

- **Spot AF.** This mode allows you to pick a single autofocus point and then use just a small part of the actual focus point for a more accurate focus point.

- **AF Point Expansion 4 Point.** This mode takes the selected focus point and makes it bigger by adding four of the surrounding focus points.

- **AF Point Expansion 8 Point.** In this mode, you get a larger cluster of focus points that all work together. It uses the selected focus point and then eight of the surrounding points.

- **Zone AF.** In this mode, you pick a zone of focus points and the camera then uses all the points in that area for autofocus. The camera will pick the point to use and will focus on the object closest to the camera.

- **Wide Zone AF.** In this mode, the camera uses a larger selection of the autofocus points.

Figure 2.6

Using a single point allows you to make sure you are focused on the subject.

Canon 5D Mark III • ISO 800 • 1/60 sec. • f/2.8 • 24–70mm lens

- **Automatic AF Point Selection.** In this mode, the camera uses all the focus points in the camera and then picks the one it thinks is on the subject. The camera will focus on the point that has detail and is closest to it.

Canon Live View Focus Modes

The following are the focus modes available on the Canon cameras in Live View mode.

- **Manual Focus (M).** In this mode, you focus the camera using the focus ring on the lens.
- **Quick AF Mode.** This mode actually uses the phase-detection autofocus module by flipping the mirror back down so that the light coming in through the lens can be seen by the AF module. It momentarily disrupts the live view, but it is quick and accurate.
- **Live AF Mode.** This mode uses contrast detection on the image sensor to achieve focus, making it slower and less accurate than when shooting through the viewfinder.
- **Live AF Mode with Face Detection.** This mode uses contrast detection on the image sensor to try to find faces and focus automatically on them. It works well when used with clearly identifiable faces that are upright, but can be much slower than the Live AF mode and very much slower than Quick AF mode.

Canon Live View Focus Areas

The Canon terms for the autofocus areas when using Live View are FlexiZone-Single and FlexiZone-Multi:

- **FlexiZone-Single.** In this mode, you pick the point that the camera uses for autofocus.
- **FlexiZone-Multi.** In this mode, the camera automatically picks the autofocus point to use, usually locking focus onto the subject closest to the camera. With some camera models, you can limit the camera's choice of where it focuses when using the advanced exposure modes by using one of several focus zones.

Sony

Sony has always pushed the autofocus capabilities of its cameras and offered some novel technological functions. The company even produced cameras that had a sensor under the viewfinder so that when you raised the camera to your eye, the autofocus engaged without your having to first press the shutter release button halfway down. The idea was to get the camera focusing faster so that you would not miss any shots. Sony also created the Fast Hybrid AF system in its newer cameras, but that system is only available with compatible lenses.

Sony Focus Modes

The following are the focus modes on the Sony cameras, including the newer full-frame mirrorless offerings:

- **MF (Manual Focus).** In this mode, the camera does not engage the autofocus and you have to turn the focus ring on the lens to focus the camera.

- **AF-C (Continuous Autofocus).** In this mode, the camera continues to focus as long as you hold the shutter release button halfway down. It is best suited for moving subjects.

- **AF-S (Single-Subject Autofocus).** This mode locks the focus on the subject when you press the shutter release button halfway down. If the subject or the camera moves after the focus is locked, the autofocus will not re-engage.

- **AF-A (Automatic Autofocus).** In this mode, the camera decides if the subject is moving or still and the autofocus will either continuously autofocus or use the single-subject autofocus.

- **DMF (Direct Manual Focus).** This mode allows you to manually fine-tune the focus after the camera locks onto the subject. It works similarly to AF-S but allows you to adjust the lens after the focus is locked.

Sony Focus Areas

The Sony camera focus areas are:

- **Wide.** The camera picks the focus point from anywhere on the screen. In **Figure 2.7**, you can see the Wide focus area used for the landscape image.

- **Zone.** You get to pick the zone from which the camera then chooses the focus point.

- **Center.** This mode uses just the center focus point.

- **Flexible Spot.** In this mode, you get to pick the point the camera uses from anywhere in the frame and you get to decide on the size of the focus point— either small, medium, or large.

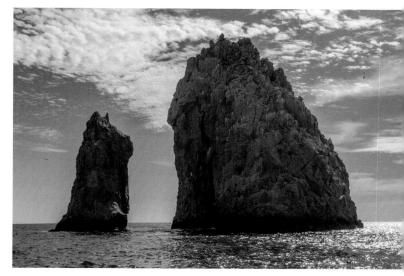

Figure 2.7

I used the Wide group AF area to photograph the landscape and placed it over the giant rock to give the camera as much information to work with as possible.

Sony · ISO 400 · 1/500 sec. · f/8.0 · 24–70mm lens

Exposure and Focus

Every photograph is created by the sensor (or film) in the camera as it records the light being bounced off the subject. The right amount of light allowed to reach the sensor creates a photo that isn't too bright (*overexposed*) or too dark (*underexposed*). The amount of light is controlled by the size of the opening in the lens (*aperture*) and the amount of time the shutter is open (*shutter speed*). The third factor is the *ISO*, which controls how sensitive to light the sensor or film is. The aperture and shutter-speed settings can also have an effect on the focus in your images. Understanding how they work and how the focus is affected can help you get the results you want.

Aperture and Focus

The *aperture* is the size of the opening in the lens that allows light through to reach the camera's sensor. The bigger the opening, the more light is allowed in through the lens. This might not seem like it has much to do with focus, but it does. The size of the aperture determines the depth of field, and depth of field controls how much of the image is in focus.

When you focus on a subject, there is one point of actual focus that an area in front of and behind the subject will also seem to be in acceptable focus. The size of that area is called the *depth of field*. The depth of field can be very shallow, where only a small sliver of the image is in focus, or it can be deep, where everything in the image from the foreground to the background will seem to be in focus.

The bigger the opening in the lens, the shallower the depth of field is, while the smaller the opening in the lens, the less light is allowed through and the greater the depth of field. As you can see from **Figure 2.8**, the area in acceptable focus is one-third in front of the point of focus and two-thirds behind it.

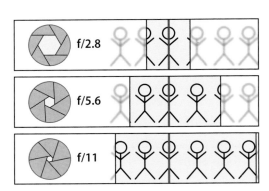

Figure 2.8

The focus plane, depicted by the red line, shows how much is in focus in front of and behind the focus point.

As you can see in **Figure 2.9**, a shallow depth of field makes the subject stand out. For the photo of the hurdler, I used an aperture of f/4.0 and kept the focus point right on the hurdle, then took the photo as the runner was right in the middle of the jump.

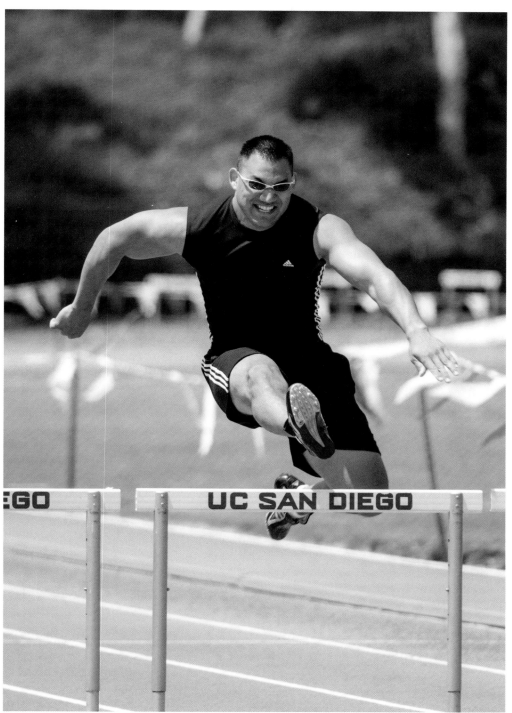

Figure 2.9
The hurdles are fun to photograph. By pre-focusing right on the hurdle, I was able to catch the runner as he cleared the hurdle.

Nikon D2X · ISO 800 · 1/800 sec. · f/4.0 · 300mm lens

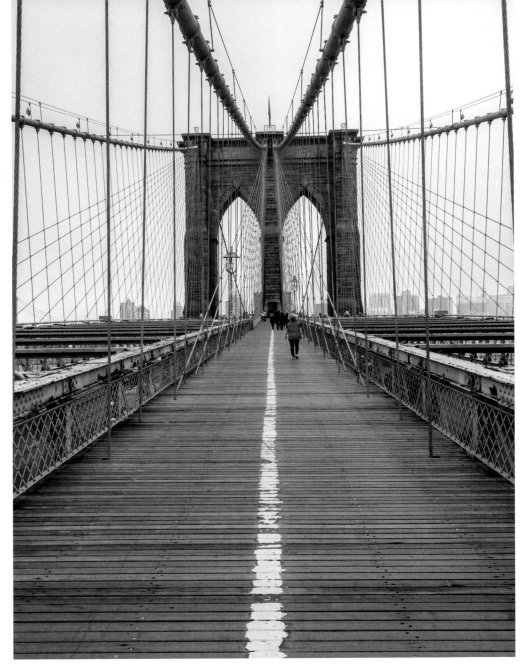

Figure 2.10
I photographed the Brooklyn Bridge using a deep depth of field and a wide-angle lens to make everything look as if it was in focus.

Nikon D2x • ISO 400 • 1/180 sec. • f/11 • 17–55mm lens

A deep depth of field can make everything in the photo look like it is in focus, but it's really not. Take **Figure 2.10**: I photographed the Brooklyn Bridge with a wide-angle lens and an aperture of f/11, making it seem that everything from the foreground to the background was in focus. The reality is that the person walking in the red top is the focus point. Everything in front of and behind that point is progressively becoming more out of focus.

Shutter Speed and Focus

The shutter speed can affect the focus of your image in a very basic way. If the shutter speed is too slow and the subject or the camera moves during the exposure, then the image will not be sharp.

DSLRs have a shutter speed that can range from 30 seconds to 1/4000 of second, some even go as fast as 1/8000 second. The shutter speed needs to be fast enough to freeze the action, but it also needs to be fast enough to negate any camera shake. When you hand-hold a camera, slight, unintentional movements become more pronounced with longer focal lengths. These little movements are referred to as camera shake and can cause your images to be blurry even if the subject is still. The rule of thumb is to use a shutter speed that is 1/focal length, so if you are shooting a 200mm lens, then the minimum shutter speed to avoid camera shake would be 1/200 second. This does not take into account the speed of the subject. In **Figure 2.11**, the shutter speed was too low to freeze the man walking down the street, making him slightly blurred.

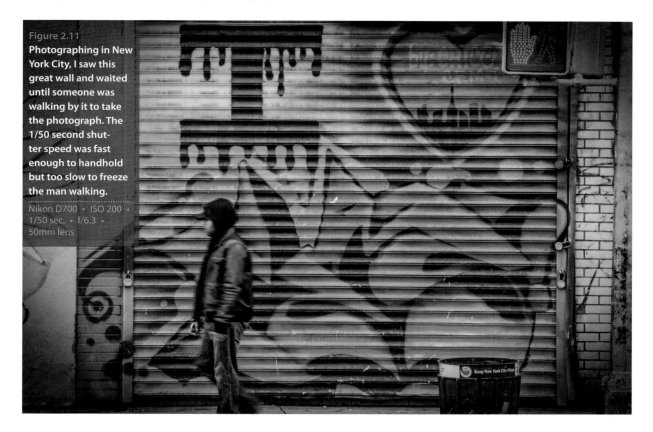

Figure 2.11

Photographing in New York City, I saw this great wall and waited until someone was walking by it to take the photograph. The 1/50 second shutter speed was fast enough to handhold but too slow to freeze the man walking.

Nikon D700 · ISO 200 · 1/50 sec. · f/6.3 · 50mm lens

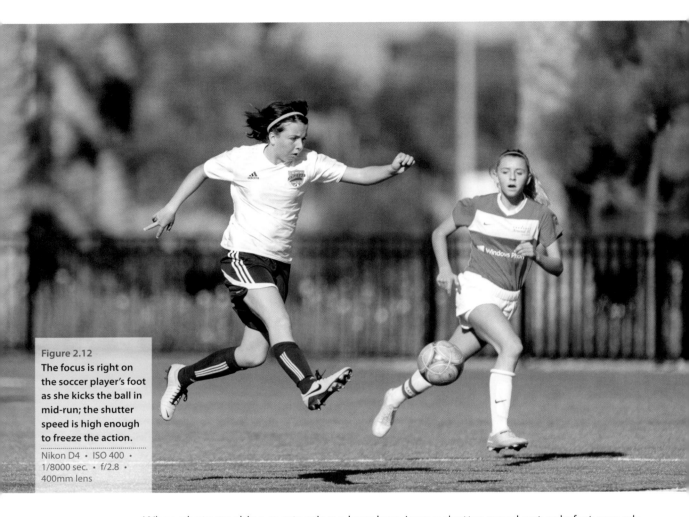

When photographing sports using a long lens, I use a shutter speed not only fast enough to freeze the action but also fast enough to avoid any camera shake. For example, the photo of the soccer players in **Figure 2.12** was shot at 1/8000 of a second shutter speed, which not only froze the girl in the air but also avoided any camera shake.

Chapter 2 Assignments

Learn Your Camera's Terminology

Do you know what your camera calls the focus modes and what the different focus areas are? You need to know which modes are which and what terminology your camera uses. Luckily, this is easy to find: Consult your camera manual or one of the camera-model-specific *Snapshots to Great Shots* books.

Change Shutter Speeds

Shoot the same scene using different shutter speeds to see how your camera handles the focus and, more importantly, to find out how steady you can hold the camera and lens without producing visible camera shake.

Experiment with Depth of Field

Shoot the same scene using both a shallow depth of field and a deep depth of field. You will see the difference in what is in focus and what isn't when you use different apertures.

Share you results with the book's Flickr group!
Join the group here: flickr.com/groups/focusandautofocus_fromsnapshotstogreatshots

Nikon D700 · ISO 200 ·
1/250 sec. · f/5.6 ·
70–200mm lens

3
Focus Controls and Modes

A closer look at the different focus controls and modes

It is vital to understand the various focus modes, as well as where and how to adjust them on your camera and lens. The good news is that there are actually just a few focus modes, and they can easily be sorted into three categories: manual focus for the times when autofocus doesn't work, autofocus for moving subjects, and autofocus for non-moving subjects.

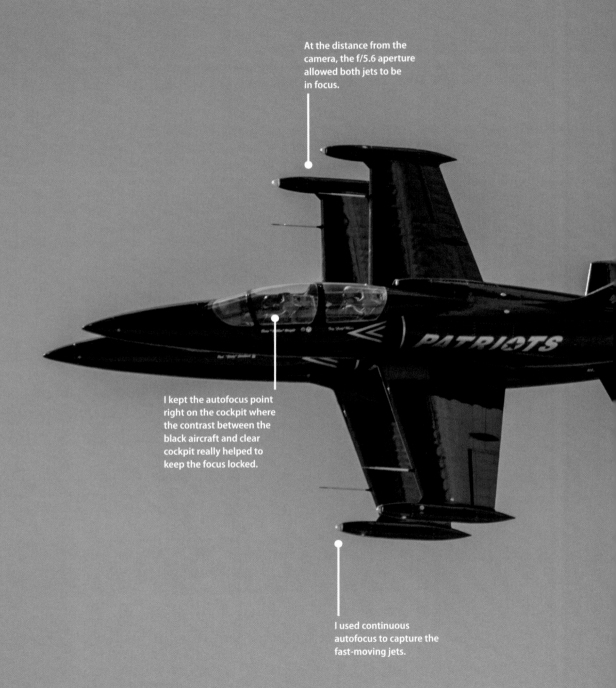

At the distance from the camera, the f/5.6 aperture allowed both jets to be in focus.

I kept the autofocus point right on the cockpit where the contrast between the black aircraft and clear cockpit really helped to keep the focus locked.

I used continuous autofocus to capture the fast-moving jets.

Nikon D750 · ISO 400 · 1/4000 sec. · f/5.6 · 80–400mm f/4.5–5.6 lens

Photographing the Patriots Jet Team during their maneuvers required continuous autofocus and keeping the focus point on the cockpit of the lead jet.

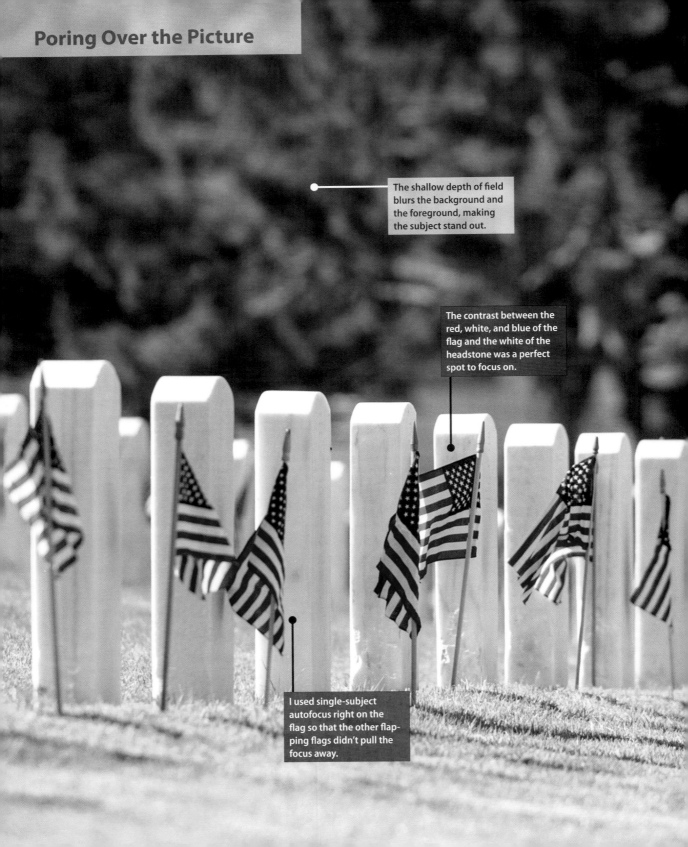

Poring Over the Picture

The shallow depth of field blurs the background and the foreground, making the subject stand out.

The contrast between the red, white, and blue of the flag and the white of the headstone was a perfect spot to focus on.

I used single-subject autofocus right on the flag so that the other flapping flags didn't pull the focus away.

When I photographed the flags that are set up at Rosecrans Cemetery every Memorial Day, I wanted to keep the focus on a single flag. I did this using a wide aperture of f/2.8 to create a very shallow depth of field, allowing the subject to stand out.

Nikon D4 · ISO 400 ·
1/800 sec. · f/2.8 ·
70–200mm lens

Focus Controls on the Camera

Every camera has focus controls, but because of the sheer number of different models, this book cannot cover the location of all the controls on all the cameras. Instead, it will discuss the general ideas behind the various controls and what you should look for when adjusting the autofocus.

AF/MF Switch

Many cameras have a switch right on the camera body, usually labeled AF/M, that turns the autofocus on and off. Not every camera has this, and many times the control is on the lens and not the camera. For example, the Canon line of cameras does not have an AF/M switch on the camera at all, but instead has the switch on the lens. The Sony A7 RII has an AF/MF button that temporarily switches the camera between autofocus and manual focus modes. It is important to know how to turn the autofocus off and back on for those situations when you need manual focus. On the Nikon cameras that have the switch, like the D4, the AF/MF switch is located on the left-front side of the camera, easily accessible with your left thumb when you're holding the camera, as seen in **Figure 3.1**.

Figure 3.1
On the Nikon D4, just flip the AF/MF lever between AF and MF to turn the autofocus on or off.

It is also important to know where the switch is, just in case the autofocus is inadvertently turned off. This happens to me more than I would care to admit, and it usually takes a few seconds of wondering what's wrong with the camera before I realize that the autofocus is just turned off and I'm in Manual mode.

AF Mode Selector

Your camera has a control that allows you to switch between the different autofocus modes. Being able to change the autofocus mode allows you to always pick the right mode for the situation. Check the manual that came with your camera to determine not only how to change the autofocus mode but also how to tell which autofocus mode the camera is in at any given time.

For example, to change the autofocus mode on the Nikon D750, you press the button in the middle of the AF/MF switch and rotate the rear command dial to cycle through the AF modes. As you rotate through the autofocus modes, the display on the top of the camera, as well as through the viewfinder, lets you know the currently selected mode.

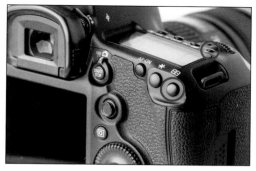

Figure 3.2
When the AF Area button (on the back of the camera) is pressed, you can use the main dial (on top of the camera) to select the desired autofocus mode.

On the Canon EOS 5D Mark III, you press the AF Area button and rotate the main dial to select the desired autofocus mode, as shown in **Figure 3.2**. You can also use the AF Area button and the M-Fn button to pick the AF mode if you set that up in AF Menu in the AF area selection method.

On the Sony A7 RII, you can pick the autofocus mode using the Menu button to open up the Camera Settings, then select the Focus Mode option and pick from the four choices: Single-shot AF, Continuous AF, DM Focus, and Manual Focus, as seen in (**Figure 3.3**).

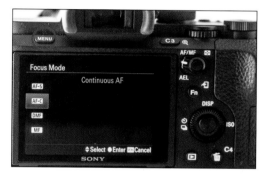

Figure 3.3
The Sony AF menu system shows the Focus Mode menu selections.

AF Area Selector

Two focus area controls need attention: The first determines the number of focus points that the camera will use and the second determines which of the points is in use. On the Canon EOS 7D Mark II, the Autofocus Area Selection lever cycles through the available AF areas every time you push it to the right. You can also change the autofocus area by pressing the M-Fn button, which changes the autofocus area each time it is pressed. On the Nikon D750, press the AF-MF button and rotate the front dial to cycle through the available autofocus areas. The number of points is shown on the top screen and through the viewfinder. In **Figure 3.4**, for example, the top screen shows that I have selected AF-C for continuous autofocus and am using 9 focus points.

On the Sony A7 RII, you choose the focus area by pressing the Menu button, then open the Camera Settings menu and choose the Focus area to select one of the autofocus areas (**Figure 3.5**).

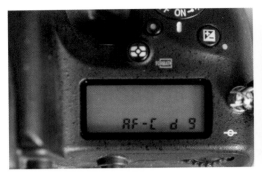

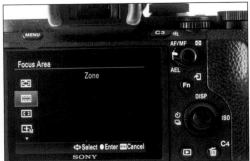

Figure 3.4
The top screen of the Nikon D750 shows the current focus mode and focus area when you push the AF/MF button. The same display is shown in the viewfinder.

Figure 3.5
The Sony menu system shows the AF area mode selection.

When you pick an autofocus area that allows you to select the focus point or points used, you need to be able to select that point (or those points) from those available. On Nikon cameras, a four-way rocker switch allows you to navigate through the focus points. It works just like a joystick, enabling you to push up, down, left, or right. Some of the higher-end professional cameras actually have a small, dedicated joystick on the back of the camera (**Figure 3.6**).

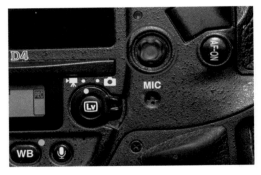

Figure 3.6
The small joysticks on the back of the D4 are dedicated controls that enable you to move the focus point easily.

Lens Controls and Features

Many camera and lens manufacturers put controls on the lens that affect the focus, which makes a lot of sense because the lens is actually responsible for the focus.

Focusing Ring

The focusing ring on the outside of the lens controls the position of the elements inside the lens. You just turn the focusing ring left or right to focus the lens (**Figure 3.7**). The focusing ring may or may not work all the time, depending on how the internal focusing mechanism works. When autofocusing is turned on, either the motor in the lens or the motor in the camera is adjusting the focusing. To protect mechanism, the focusing ring is disengaged so you can't turn it. This means that if you turn the focusing ring, nothing happens. Some lenses allow you to manually adjust the focus at the same time that the

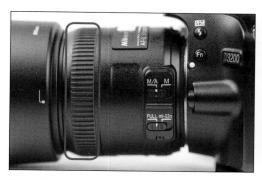

Figure 3.7
The focusing ring on the lens allows you to manually adjust the focus.

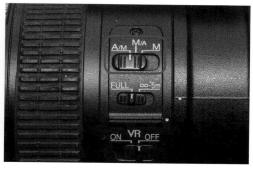

Figure 3.8
This switch on the 70–200mm f/2.8 Nikkor lens allows you to set the lens to either autofocus or manual focus. But there are two autofocus modes, and they both allow the autofocus to be overridden by manually turning the focus ring. The only difference is the sensitivity of the focus ring; it is much lower in the A/M than in the M/A setting.

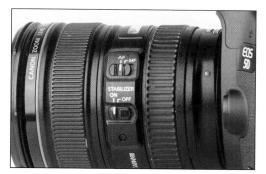

Figure 3.9
The AF/MF switch on the Canon lens enables autofocus and turns it off.

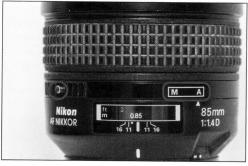

Figure 3.10
The AF/MF switch on the Nikkor 85mm lens allows you to switch between M (Manual focus) and A (Autofocus) by pressing in the silver button and turning the ring.

camera is using the autofocus, and you can manually change the focus with the ring while still in the autofocus mode. Some lenses allow you to set which type of focus, manual or auto, takes precedence (**Figure 3.8**).

AF/MF Switch

The AF/MF switch on the lens enables and disables the autofocus. All of the Canon EF and EF-S lenses with autofocus have this switch (**Figure 3.9**); some of the Nikon lenses have it as well (**Figure 3.10**).

The AF/MF switch can also have some other options to control how the focusing ring and autofocus work together, as discussed in the previous section. The most important piece of information is to be aware that the switch exists on the lens. If you are having trouble with the camera autofocusing, you need to make sure that it is turned on here.

Minimum Focusing Distance

The minimum focusing distance is the shortest distance between the lens and subject at which you can still achieve focus. Get any closer to the subject, and you can't focus at all. Different lenses have different minimum focusing distances, and it's important to have an idea of how your lens measures up.

Macro lenses usually allow you to get extremely close and still achieve focus. For example, the Nikkor 105mm f/2.8 allows you to get as close as 1 foot from the subject. This allows you to get up close and personal with your subject, like the flower in **Figure 3.11**.

Regular lenses need a little more space. For example, the Canon 24–70mm f/2.8L II USM needs at least 1.25 feet. The usual rule is the longer the focal length, the greater the minimum focusing distance. The Canon EF-S 55–250mm f/4.5–5.6 IS II lens has a minimum focusing distance of 3.6 feet, and the Nikkor 70–200mm f/2.8 lens needs 4.6 feet between the lens and the subject. When I shoot with the 70–200mm lens, I have to be farther away from the subject; but the longer focal length allows me to fill the frame, as seen in **Figure 3.12**.

Figure 3.11
Using a macro lens allows me to get in tight to the subject, like this passionflower photographed with the 105mm macro lens.

Nikon D750 • ISO 800 • 1/80 sec. • f/13.0 • 105mm Macro lens

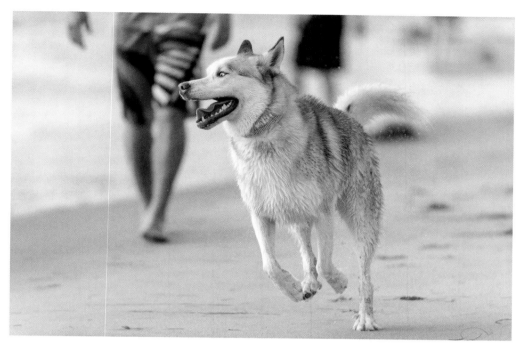

Figure 3.12

I needed to have quite a bit of distance between me and the running dog to be able to focus. The good thing is that at 200mm the dog fills the frame and the background blurs due to the shallow depth of field.

Nikon D4 · ISO 400 · 1/2500 sec. · f/2.8 · 70–200mm lens

Distance Limiting Switch

When you autofocus, the camera needs to adjust the focus of the lens as it tries to find the subject. If the camera is having a hard time finding a subject, you will often see (and hear) the lens going through the full focus range available, which can take time—sometimes a lot of time.

Some lenses have a distance-limiting switch that lets you limit the distance to which the lens will autofocus (**Figure 3.13**). This can be useful in improving the speed of the autofocus, as long as the subject stays in the set distance. When you turn on the distance-limiting switch, the lens will try to achieve focus only in the range controlled by the switch (**Figure 3.14**). This feature is not very common on lenses with shorter focal lengths, but is on lenses with longer focal lengths.

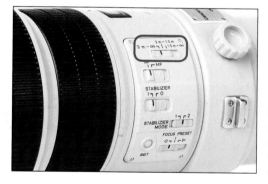

Figure 3.13

The distance-limiting switch on the Canon 400mm lens gives you three choices: from 3 meters to infinity, from 3 meters to 10 meters, and from 10 meters to infinity. (Photo copyright Jerod Foster.)

Figure 3.14

The distance-limiting switch on the Nikon 70-200mm allows you to either focus through the full range of focus distances or limit focus from infinity to 5 meters or 16.5 feet; anything closer than 5 meters will not be in focus.

Focus Presets

Many super telephoto lenses have the ability to store a focus preset that allows you to quickly go back to that predetermined focus distance with the press of a button. Simply focus on a point that you know you want to come back to and set it as the pre-focus point. While shooting, you then can push the pre-focus button or turn the pre-focus ring, and the lens quickly changes the focus back to the pre-focus point.

This feature is not very common at all, but if you are using one of the super telephoto lenses that does have it, take a few minutes to practice using it. Focus presets can make a big difference when shooting anything that takes place at known but varying focus distances. For example, let's say that you are shooting a horse race, and you want to make sure that you capture the horses coming around the last turn. You can set the focus preset to where the horses come around the turn, then just go back and shoot the start of the race. When the horses are getting close to the last turn, you can just activate the preset, which gets you focused fast on the spot the horses will be coming from. Keep in mind that this only works when the camera position doesn't move, because the focus distance needs to be the same from when you set the preset to when you use it.

Vibration Reduction/Image Stabilization

Lens technology continues to make advances in materials and technology to allow photographers to capture the sharpest images possible. One of the major advances is the introduction of Vibration Reduction (VR, Nikon lenses) (**Figure 3.15**) and Image Stabilization (IS, Canon lenses) (**Figure 3.16**), features that allow you to use slower shutter speeds and avoid camera shake. Sony has similar technology, but it is built into the camera and not the lenses.

Lens Compatibility

Not all lenses will autofocus on every camera body. For a lens and camera to autofocus properly together, there needs to be a motor somewhere in the equation that adjusts the focus automatically. The camera tells the motor which way to focus the lens. Some camera bodies have motors built into the camera body, but many of the consumer models do not. Many lenses have motors built into them, but some do not. So when you have a lens that does not have a motor mounted on a camera that has no motor, you have no way to adjust the lens.

In very basic terms, when you turn the VR or IS on, sensors in the lens measure the small vibrations as you try to hold the camera steady while you focus, and then they try to counteract that motion when you take the photo. This technology works well for stationary subjects but not for moving ones. So if you are shooting a moving subject, turn the VR or IS off. I have also found that there is a slight, very slight, lag between when I push the shutter release all the way down and the photo is taken when using VR. This usually happens when I am shooting a moving subject and the VR is turned on inadvertently or is still on from a previous shoot.

Figure 3.15
The VR controls on the Nikon 70–2000mm lens enable you to choose between Normal and Active mode, depending on what you are shooting.

Figure 3.16
With the Image Stabilization controls on the Canon 400mm lens, you can easily turn the IS on or off with a quick slide of the switch. (Photo copyright Jerod Foster.)

Single-Subject Autofocus

Single-subject autofocus mode is called AF-S on Nikon and Sony, and One-Shot AF on Canon. The names might be different, but this mode works the same on all three brands.

What Is Single-Subject Autofocus?

In this mode, the camera focuses on the subject when you press the shutter release button halfway down. Once it locks on focus, it stops trying to keep the subject in focus. If the subject or the camera moves before the shutter release is pushed all the way down and the photo is taken, the camera does not try to refocus. A lot of cameras allow you to set the camera so it beeps when the focus is achieved, and you can set many cameras to not take the photo until the focus is locked. I have my cameras set up so that when they are in AF-S mode, the shutter will not release until the camera has locked focus.

When to Use Single-Subject Autofocus

This is the mode to use when photographing subjects that don't move, like still-life scenes or landscapes. It can also be used for portraits as long as you take the photo right after achieving focus so that the subject doesn't have time to move (**Figure 3.17**).

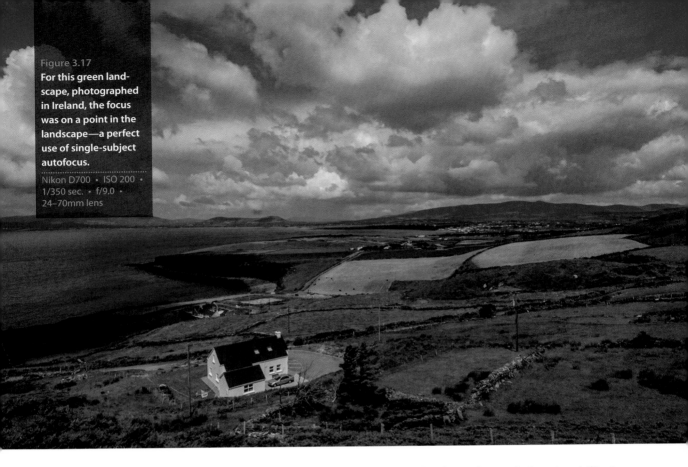

There are some real advantages to using this mode, the main one being the ability to recompose your image and still keep the subject in focus as long as you don't change the distance from the subject to the camera.

Consider the photos of the flower in **Figures 3.18** and **3.19**. You can see in the first image that the focus point used was right in the center of the frame. Once the focus was achieved, I moved the camera sideways to create the composition seen in Figure 3.19, placing the subject where there was no focus point originally. The flower stayed in focus because the distance from the camera and the flower did not change between the two images.

On the Nikon system, using the single-subject autofocus (AF-S) combined with a Nikon Speedlight in low light will trigger the active autofocus light. This light measures the distance from the camera to the subject, enabling the camera to focus even in the dark. The Canon system has the same capability and uses an IR AF-assist beam that works when the camera is in One-Shot AF mode. These capabilities are not available in continuous autofocus mode.

Figure 3.18
The orchid is centered in the frame and is easily focused on because the focus points are in the center.

Nikon D750 · ISO 800 · 1/250 sec. · f/4.0 · 70–200mm lens

Figure 3.19
Because there were no focus points where I wanted the flower in the frame, I recomposed after focusing. Starting with the same focus as in Figure 3.18, I moved the camera sideways to create a more interesting composition.

Nikon D750 · ISO 800 · 1/250 sec. · f/4.0 · 70–200mm lens

The single-subject focus mode works really well when shooting a static subject, even with moving subjects in the foreground. For example, when shooting a landscape with moving plants in the foreground, the focus needs to stay on the subject and not get caught up on the moving items closer to the camera. In **Figure 3.20**, the focus needed to stay on Mike as he worked on creating the guitar. The machine he used created a lot of moving sawdust and the spinning bit was closer to the camera, so I made sure that the focus was on Mike. I used AF-S mode, and once the focus was locked on Mike, I took the photo.

Finally, the single-subject focus mode uses less battery power because the focusing motor doesn't need to run continuously to keep the subject in focus. This can be the difference between shooting a few more frames with the last bit of battery power and not getting those images.

Figure 3.20
While photographing Mike Lipe creating one of his custom guitars, I wanted to make sure that the moving items didn't pull the focus away from his face. I used the AF-S setting and made sure the focus was on his face.

Nikon D700 · ISO 100 · 1/80 sec. · f/8.0 · 85mm lens

When to Avoid Single-Subject Autofocus

This mode is made for subjects that are not moving, so using it for action, sports, or anything with a subject that is in motion will result in blurry photos. There are two things that can happen when trying to photograph a moving subject in the single-subject mode: The camera will take blurry photos, or you will not be able to take any photos at all. In the last section, I mentioned that you can set your camera to release the shutter only after the camera has achieved focus. If you have this turned on, then the camera will not fire as the lens goes through the available focus distances trying to find a static subject to focus on. If it does and allows you to press the shutter release button all the way down, chances are the photo will be of something behind or in front of the actual moving subject.

Continuous Autofocus

On the Sony and Nikon system, continuous autofocus mode is called AF-C, while it's AI-Servo on the Canon system, but it all the names mean the same thing: continuous autofocus.

What Is Continuous Autofocus?

In the continuous autofocus mode, the camera starts to focus as you press the shutter release button halfway and continues to track and focus on the subject until the shutter release is pressed all the way down. This mode makes it possible to capture action photographs like the horse running at full speed in **Figure 3.21**.

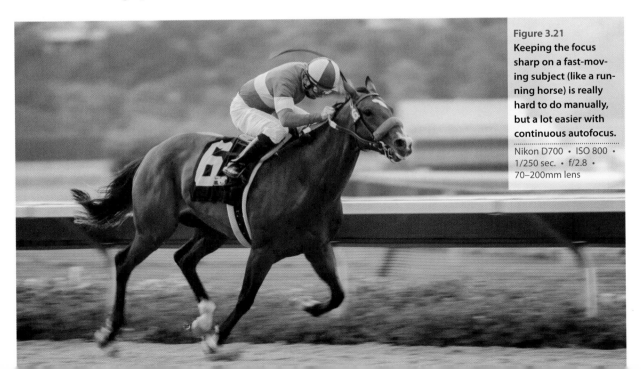

Figure 3.21
Keeping the focus sharp on a fast-moving subject (like a running horse) is really hard to do manually, but a lot easier with continuous autofocus.
Nikon D700 • ISO 800 • 1/250 sec. • f/2.8 • 70–200mm lens

When to Use Continuous Autofocus

Continuous autofocus is used for moving subjects and is suited for sports, action, concerts, and any time the subject is motion while you are photographing it. The surfer in **Figure 3.22** was photographed using continuous autofocus to keep track as he cut back on the top of the wave. I kept the focus point right on the surfer's head and shoulder, where the contrast between the dark wetsuit and the lighter face would give the camera something to focus on. The same idea worked in **Figure 3.23**, where I kept the focus point right on the face and hair of the drummer to give the camera something to focus on. The camera kept focusing right up until I pressed the shutter release button all the way down, as both drumsticks were in the air.

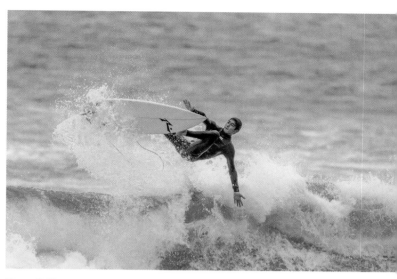

Figure 3.22
Continuous autofocus allowed me to track the surfer's whole ride and photograph him as he got air off the top of the wave.

Nikon D4 · ISO 640 · 1/1000 sec. · f/2.8 · 400mm lens

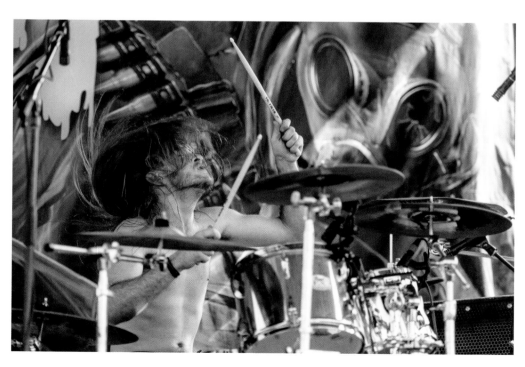

Figure 3.23
Musicians rarely stay still, so using continuous autofocus makes it possible to capture them in mid-performance.

Nikon D4 · ISO 400 · 1/1250 sec. · f/2.8 · 70–200mm lens

Figure 3.24
The focus point is directly on the eye of the dog, and because I was shooting in AF-C, even if the dog moved I would still have focus locked.

Nikon D750 • ISO 800 • 1/1250 sec. • f/2.8 • 70–200mm lens

Some of my favorite subjects to photograph are my dogs. (I even wrote a book on pet photography.) Although my dog will sit still when I tell him to, he often jumps up or moves erratically, which is why I always use continuous autofocus when photographing him. This allows me to get more in-focus shots no matter what he does when the camera is pointed at him. In **Figure 3.24**, I kept the focus point right on the dog's eye so that if he jumped up, he would still be in focus.

When to Avoid Continuous Autofocus

There are times when using continuous autofocus will not give you the desired results because you don't want the camera to keep focusing as you move it. Whenever you want to focus and recompose, you cannot use continuous autofocus, as the camera will keep focusing when you start to recompose (**Figure 3.25**). Compositionally, it means that you can't use continuous autofocus for any subject that falls outside of the focus point area.

Continuous autofocus is not as reliable as single-subject autofocus due to the way it works. Continuous autofocus is constantly adjusting the focus distance of the lens, but the camera can only guess at which way the subject is moving, so it always plays catch-up to the actual subject movement. The high-end professional cameras do a better job on autofocusing speed than the lower-end cameras, but they are all faster and more accurate than when I try to manually focus on fast-moving subjects.

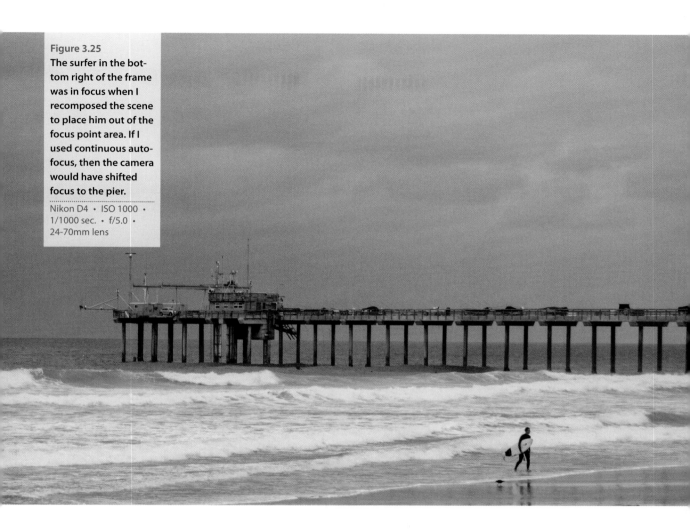

Figure 3.25
The surfer in the bottom right of the frame was in focus when I recomposed the scene to place him out of the focus point area. If I used continuous autofocus, then the camera would have shifted focus to the pier.

Nikon D4 · ISO 1000 · 1/1000 sec. · f/5.0 · 24-70mm lens

Single/Continuous Hybrid Mode

There is a third autofocus mode on most cameras that is a combination of single-subject and continuous autofocus. Trying to be the best of both, this mode is called AF-A in the world of Nikon and Sony and AI Focus AF in Canon land.

In this mode, you press the shutter release button halfway down, and the camera automatically decides if the subject is moving or still, and then uses the appropriate autofocus mode (**Figures 3.26** and **3.27**).

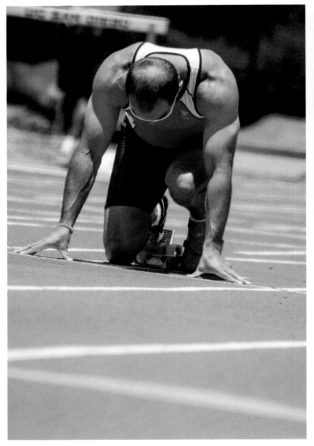

Figure 3.26
The runner getting ready in the blocks before the gun could be considered a stationary subject, as he is not moving—yet. Because the camera doesn't know that the runner is about to move, it wouldn't keep focusing because right now the runner is still.

Nikon D700 · ISO 200 · 1/500 sec. · f/5.3 · 80–400mm lens

Figure 3.27
The runner leaving the blocks at the start of the race is in motion and the camera would continue to focus as the subject moved.

Nikon D700 · ISO 200 · 1/500 sec. · f/5.3 · 80–400mm lens

This is a great mode to use if you are starting out and not sure which of the modes to use, but it is my least favorite because it gives control to the camera, not the photographer. Some of the higher-end professional camera models, like the Nikon D4, do not have this option, as most professional photographers don't leave the focus decisions to the camera.

Chapter 3 Assignments

Turn the Autofocus On and Off

Mastering focus means that at times you will want to turn the autofocus off. Locate the AF/MF switch on your camera and lens combination. (Remember that the Canon lenses have the switch, but for Nikon cameras, it could be on the body or the lens, or both.) Shoot the same subject using autofocus and then manual focus. If you get really good, you could switch between the two without taking your eye from the viewfinder.

Switch Autofocus Modes

Learn how to switch between the various focus modes on the camera so that you can change between continuous and single-subject modes quickly. Knowing when to use each mode is important, but if you don't know how to switch modes, you won't be able to get the shot.

Experiment with the Different Autofocus Modes

The best way to see exactly how the modes work is to try them. Go out and take photos of both moving and still subjects using both modes to see how they are different and how they deal with subjects in motion and those that are still.

Share you results with the book's Flickr group!
Join the group here: flickr.com/groups/focusandautofocus_fromsnapshotstogreatshots

Nikon D700 • ISO 200 •
1/250 sec. • f/5.6 •
70–200mm lens

4
Autofocus Points

What are autofocus points and how to use them

Your camera uses autofocus points to focus on the subject in your photo. DSLR cameras have multiple autofocus (AF) points, and as the photographer, you get to decide which point or points to use. There are actually different types of AF points, and they are not all created equal. This chapter is here to explain why cameras have multiple AF points, as well as to help you decide which of those points to use.

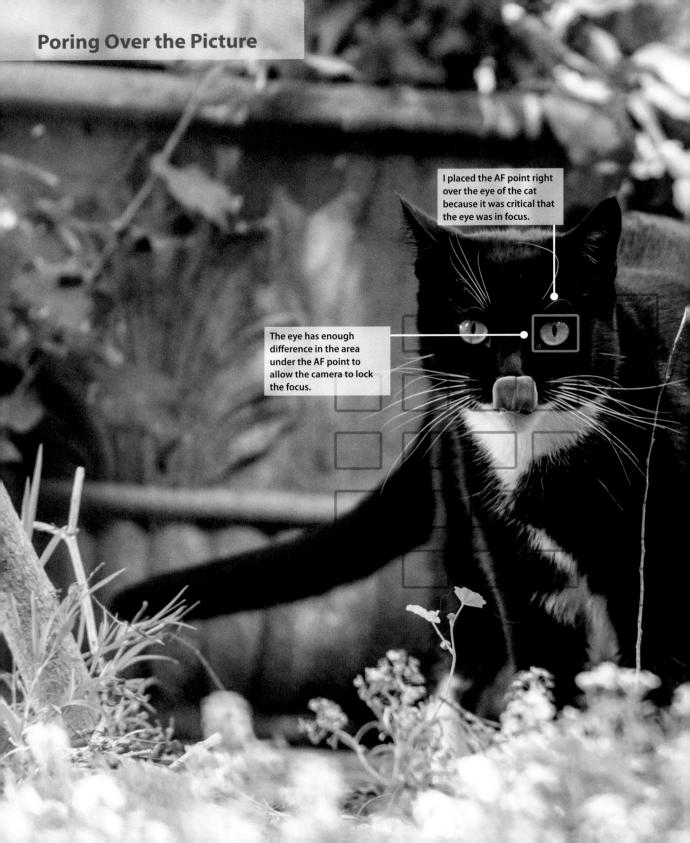

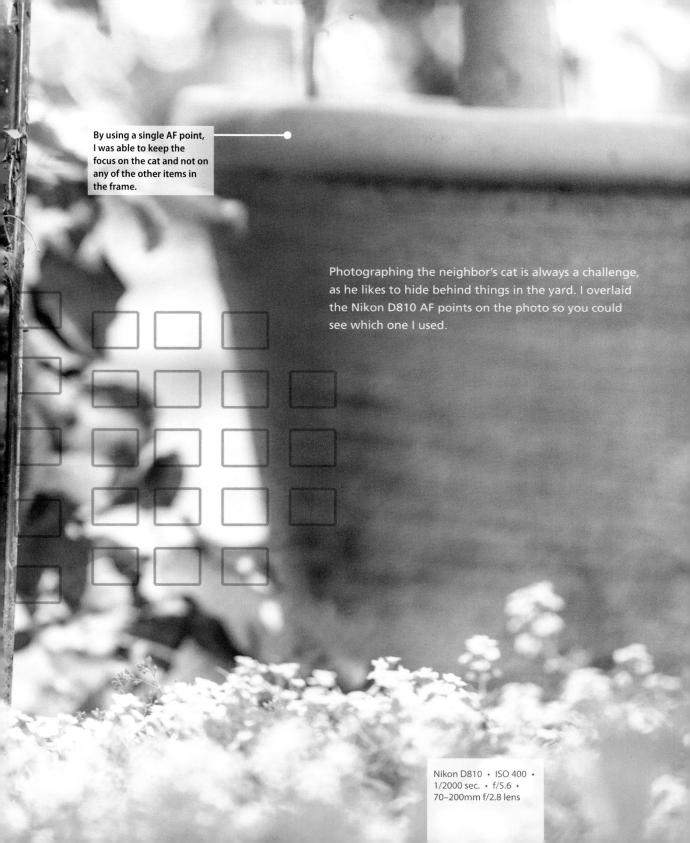

By using a single AF point, I was able to keep the focus on the cat and not on any of the other items in the frame.

Photographing the neighbor's cat is always a challenge, as he likes to hide behind things in the yard. I overlaid the Nikon D810 AF points on the photo so you could see which one I used.

Nikon D810 · ISO 400 ·
1/2000 sec. · f/5.6 ·
70–200mm f/2.8 lens

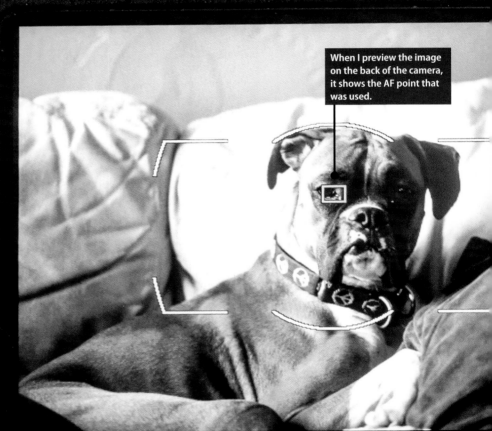

The LCD of this Nikon D750 shows a recently taken photo. You can see the image, the focus point used, and the controls used to select that AF point.

When I preview the image on the back of the camera, it shows the AF point that was used.

②141ND750 _AHP1114. NEF
10/27/2015 09:17:07 FX

AE-L
AF-L

info

6/7

L

OK

This rocker switch allows me to move the focus point.

This switch allows me to lock the selected focus point so that it can't be inadvertently changed.

Lv

RAW
6x4016

What Are Focus Points?

Each of the autofocus (AF) points matches a sensor in the autofocus module in the camera, and each of the sensors measures the light coming in through the lens to see if it is the same on the left and right (or top and bottom). When the light is the same on both sides of the sensor, the spot that the sensor is over in the frame is in focus.

Some cameras have just a few focus points, like the older Nikon D3200, which has 11 (**Figure 4.1**). Other cameras have a lot, like the Canon EOS 5D Mark III, with 65 AF points (**Figure 4.2**), and the Nikon D810, with 51 AF points (**Figure 4.3**). The interesting thing to note is that although the higher-end cameras have more focus points, they don't actually cover that much more of the frame.

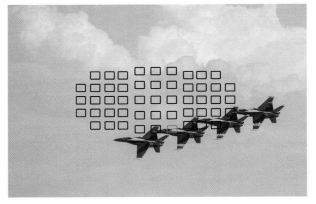

Figure 4.1
The Nikon D3200 has 11 focus points, with the lower-left point active in this image.

Figure 4.2
The Canon EOS 5D Mark III has 61 focus points, giving you more options as to where you can place the focus points, but they are still clustered in the middle of the frame.

Figure 4.3
The Nikon D810 has 51 AF points spread through the center of the frame.

Focus Point Types

There are a lot of terms thrown around when it comes to describing the autofocus points, but the two most important are *linear* (also called *line*), and *cross-type*. There is a good chance that your camera has a mix of both types of sensors, and it helps to know which type is used where. For example, the Nikon D7100 has 51 autofocus points, with 15 of them being cross-type and the other 36 being linear (**Figure 4.4**).

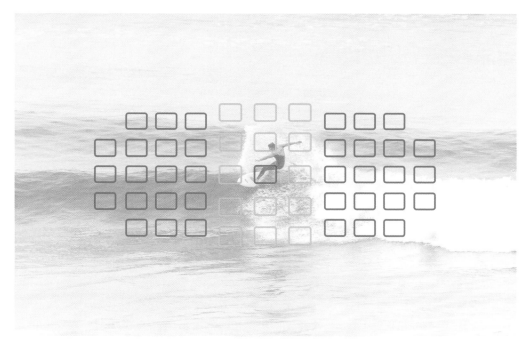

Figure 4.4
Nikon D7100 has 51 AF points: 15 cross-type and 36 linear AF sensors. The sensors in green are the linear AF sensors, while those shown in orange are the cross-type. The center AF point, shown in red, is usable as a cross-type sensor when f/8.0 is the maximum aperture.

Linear AF Points

Linear AF points are *single-line sensors*, also called *vertical-line sensors*, that detect the change in the contrast along a single dimension. These are more common and less accurate type of sensors, but knowing how they work can help you get the most out of them.

The linear AF points work best when used to focus on items with detail and contrast that is perpendicular to the direction of the sensor. For example, if the sensor is placed vertically in the frame, then it works best with horizontal lines. If the sensor is horizontal, then it works best with vertical lines.

Cross-Type AF Points

Cross-type AF points are basically two linear or line sensors perpendicular to each other but covering the same area. This configuration makes them more accurate, as they can detect changes in two dimensions. Because the cross-type sensors are more accurate than the linear sensors, using them for critical focusing is a better choice.

Some high-end cameras have a double cross-type AF sensor in the center of the frame that is more accurate but only usable with a lens with a maximum aperture of f/2.8 or wider.

Changing Focus Points

Having multiple focus points allows the photographer options in composition. All you need to do now is place any of the AF points over your subject, make sure that the AF point is active, then press the shutter release halfway down to activate the autofocus.

Each camera model has a different way of moving the selected AF point, but the basics are the same. There will be a control on the back of the camera that will allow you to change which AF point is active. To be a better photographer, you must be able to select the focus point you want, so you need to practice controlling which AF point is active. Read the camera manual for your camera on how to select which is the active point.

In the next chapter, I cover using AF *groups*, which use one or more of the autofocus points. For right now, however, set your camera to use a single AF point and practice changing which AF point is selected.

On the Nikon DSLRs, you control which focus point is used via a rocker switch on the back of the camera. Nikon positioned it where your right thumb would naturally rest when holding the camera, making it easy for you to move the focus point while looking through the viewfinder. The active, selected point will be highlighted in red. Press the switch to move the selected AF point up, down, left, or right, and you can even set it to make the point wrap around. For example, if you keep pressing to move the point right, it will go across the viewfinder to the right edge, then reappear on the left edge to start over again. **Figure 4.5** shows the rocker switch on the consumer-level Nikon D3200.

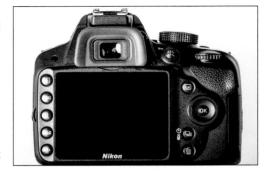

Figure 4.5
The Nikon D3200 rocker switch on the rear of the camera controls the focus point.

Some higher-end professional models feature a dedicated AF point control that acts like a miniature joystick, enabling you to quickly change focus points, but you can still use the four-way rocker switch on these models as well.

On some cameras, you can also lock the AF point selection control so that it doesn't move inadvertently, as illustrated on the Nikon D750 in **Figure 4.6**. There have been times when I have changed the focus point by mistake with my cheek as it pressed against the back of the camera. This can be really disconcerting, because the focus point will seem to move by itself—and usually at the wrong time. You do need to remember to unlock the AF point if you want to select a different one, and this, too, has caused me issues in the past, when I have forgotten that the lock was on and tried to change AF points. My initial reaction is that I have broken the camera—until I realize the lock is still engaged.

In the Canon line, changing the AF point depends on the camera model. Some of the models have a dedicated joystick that controls which focus point is selected. All you have to do is move it around with your thumb, as shown in **Figures 4.7** and **4.8**. On other models, you have to press the AF button and then use the inner toggle switch on the rear control wheel to move the AF point. If you press the AF button and rotate the wheel, you can change the focus mode, so you need to be careful that you don't change the focus mode when trying to change the focus point.

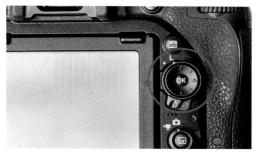
Figure 4.6
On the Nikon D750, you can lock or unlock the AF points with the rocker switch that controls them.

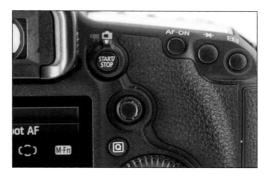
Figure 4.7
The AF point selection button on the 5D Mark III allows you to easily change the focus point. Press the button, then use the joystick shown in Figure 4.8 or the main rear dial to change the AF point.

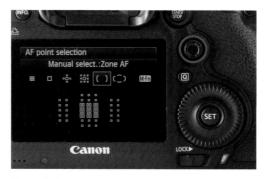
Figure 4.8
A joystick/thumb control controls the AF point on the Canon 5D Mark III.

With Sony cameras, you need to first change to Flexible Spot AF mode, and then you can use the rocker switch on the back of the camera to move the AF point, as shown in **Figure 4.9**.

Exposure and AF Points

Many cameras tie the area used for spot metering to the currently selected focus point. This allows you to use the spot meter on the same area where you are focusing, which makes sense because theoretically

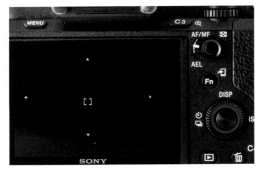

Figure 4.9
To control the AF points on the Sony, you use the thumb control on the back of the camera.

it is the most important part of the image. For example, I want to use spot metering on the motocross rider against the bright blue sky. The combination of the bright sky and dark-clothed rider makes for a great opportunity to use the spot metering, but I want to make sure that the rider isn't right in the middle of the frame. In **Figure 4.10**, you can see that placing the focus point on the helmet lets the camera spot meter on the same point on which I am focusing. This allows me to not only focus on the most important part, but also get the exposure reading from the same spot.

Figure 4.10
The AF point and the spot metering are both tied to the same area, shown in red.

Nikon D4 · ISO 400 · 1/2000 sec. · f/5.6 · 70–200mm f/2.8 lens

Aperture and Focus Points

The maximum aperture of the lens has an effect on the ability of the autofocus system and which autofocus points are actually available. The autofocus system needs light to work, which is why it has trouble in situations with very low light.

You need to understand how the camera and lens work together when you take a photo. When you mount a lens on the camera, the camera opens the aperture in the lens to the widest possible opening, allowing the most light through the lens. This helps the camera focus. When you press the shutter release button all the way down, the camera adjusts the aperture to the needed values for the proper exposure, then raises the shutter to record the image.

For example, if you are taking a photo in bright sunlight with the exposure setting set to 1/500 second, f/8.0, and ISO 400 using the 24–70mm f/2.8 lens, the camera will have the aperture set to f/2.8 until right before the shutter is raised, when it adjusts the aperture from f/2.8 to f/8.0. Right after the image is taken, the camera opens the aperture to f/2.8 again, allowing the maximum amount of light into the camera.

This gets a little more complicated if you are using a variable aperture lens for which the maximum aperture changes depending on the focal length. The camera still keeps the aperture as wide open as possible, but that changes depending on the focal length. For example, if you are using the 70–300mm f/4–5.6 lens, the camera will open the aperture up to f/4.0 when at 70mm and f/5.6 at 300mm.

Depending on the camera, some focus points don't work if the aperture is not wide enough. That means that even if the camera has more than 50 focus points, if you use a lens that doesn't open wide enough at the widest aperture, some of those points won't

work. The usual cutoff for this is between f/5.6 and f/8 and won't affect most photographers, because the widest aperture on most lenses is at least f/5.6. At times, however, especially when using a long lens coupled with a tele-extender, some of the AF points in the camera are just not going to work. If you find that this is happening to you, stick to the center points, which are usually the more sensitive ones and work even at the smaller apertures.

For example, the professional-level Nikon D4 DSLR has 51 AF points, and all of them work with lenses that open up to a maximum aperture of f/5.6, with 15 of them acting as cross-type sensors and the rest as linear sensors (**Figure 4.11**). When you use a lens

Figure 4.11
These D4 focus points are active when using lenses at f/5.6 and faster. The red AF points are cross-type, while the rest are linear.

Figure 4.12
These D4 focus points are active when using lenses that are faster than f/8.0 and slower than f/5.6. The red AF points are cross-type, while the rest are linear.

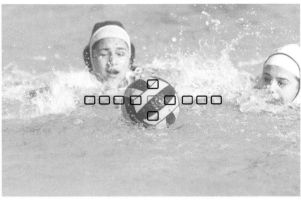

Figure 4.13
These D4 focus points are active when using lenses that have a maximum aperture of f/8.0. The red AF point is a cross-type, while the rest are linear.

that has a maximum aperture of f/8.0, 11 of the sensors work with the center AF point acting as a cross-type sensor (**Figure 4.12**). When you have a lens that has a maximum aperture slower than f/5.6 but faster than f/8.0, there are 15 AF points, with 9 acting as cross-type and the rest as linear (**Figure 4.13**).

AF Point and Camera Orientation

Some cameras allow you to store the AF point by orientation. This allows you to to change the camera from portrait to landscape or landscape to portrait, and the AF point will switch along with the camera orientation. This enables you to have a point selected when shooting portrait orientation and instantly change to a different point when shooting in landscape orientation, saving you a lot of time if you switch between the two when shooting. This is a huge time-saver for me when shooting concerts, because I don't have to keep readjusting the focus point every time I switch camera orientation.

On the Nikon cameras, this is controlled in the menu system, where you can choose to either store the points by orientation or not (**Figure 4.14**). In **Figures 4.15** and **4.16**, you can see that the same focus point is chosen no matter what the orientation, while in Figures **4.17** and **4.18**, the AF points are now dependent on the camera orientation.

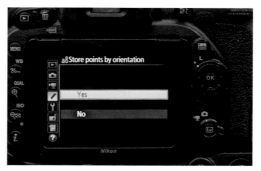

Figure 4.14
The menu system on the Nikon D750 enables you to store the focus point by camera orientation.

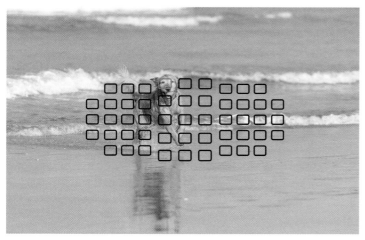

Figure 4.15
The focus point is placed squarely on the dog's face when the camera is held in landscape mode.

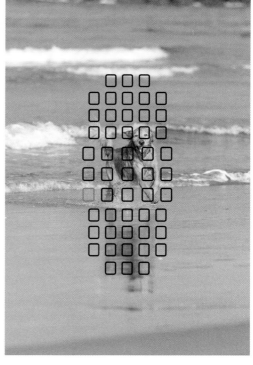

Figure 4.16
When the camera is turned to portrait mode, the focus point is way off to the side, meaning that to get it back on the eye of the dog, it will need to be moved each time the camera orientation is moved.

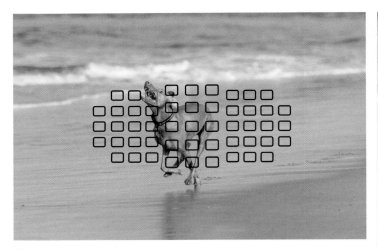

Figure 4.17
The focus point is right on the dog as it runs on the beach. When I turn the camera to portrait orientation, the camera remembers which focus point I was using, so when I turn the camera back to landscape orientation, this focus point will be active.

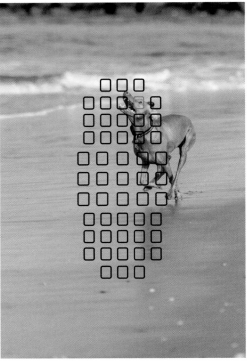

Figure 4.18
Once I set the AF point in portrait orientation, the camera will use that point until I change it. It's like having two different active points: one in portrait orientation and one in landscape orientation.

Chapter 4 Assignments

Practice Changing the Active AF Point

Mastering the controls on your camera allows you to get the shot even when working under pressure. Practice moving the focus points around the frame so that you can do it without looking at the camera.

Learn Your Camera Features

Each of the camera brands and models has different features and controls. Learn which settings control the AF points on your camera by reading the camera manual or picking up one of the camera-specific *Snapshots to Great Shots* books.

Shoot the Scene with Different AF Points

Shoot the same scene but move the focus point. This will change the focus of the image and can change the entire feel of the image. It's important to see what can happen with just a small change in where the camera focuses.

Share you results with the book's Flickr group!
Join the group here: flickr.com/groups/focusandautofocus_fromsnapshotstogreatshots

Nikon D750 · ISO 200 ·
1/250 sec. · f/5.6 ·
24–70mm lens

5
Autofocus Area Modes

A closer look at the area modes and when to use them

In the previous chapter, we looked at the *individual* autofocus points. In this chapter, you will learn about using *multiple* AF points at the same time. By setting the autofocus area mode or AF area mode on your camera, you can determine how many autofocus points to use for your shot. You can use a single AF point, all the points, or just a selected group of points. The right autofocus area mode can help you focus on the subject, but using the wrong mode can make for a very frustrating experience.

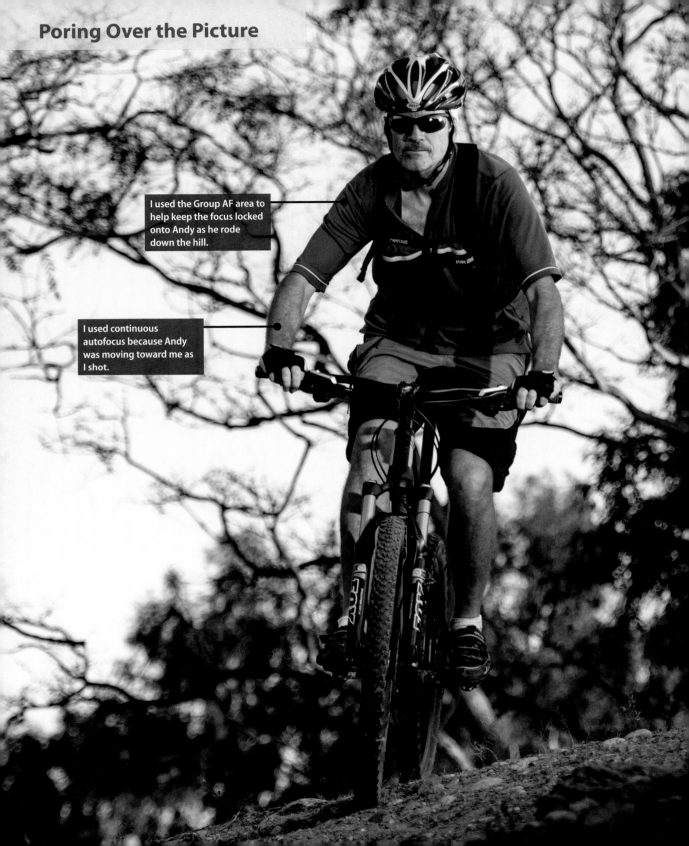

Poring Over the Picture

I used the Group AF area to help keep the focus locked onto Andy as he rode down the hill.

I used continuous autofocus because Andy was moving toward me as I shot.

Nikon D750 · ISO 400 · 1/200 sec. · f/2.8 · 24–70mm f/2.8 lens

I needed to make sure that the focus was on the rider and bike rather than the background or foreground, so I didn't use any of the automatic autofocus area modes.

Photographing a mountain bike in action meant using continuous autofocus and making sure that the AF points were on the rider and not on the surroundings.

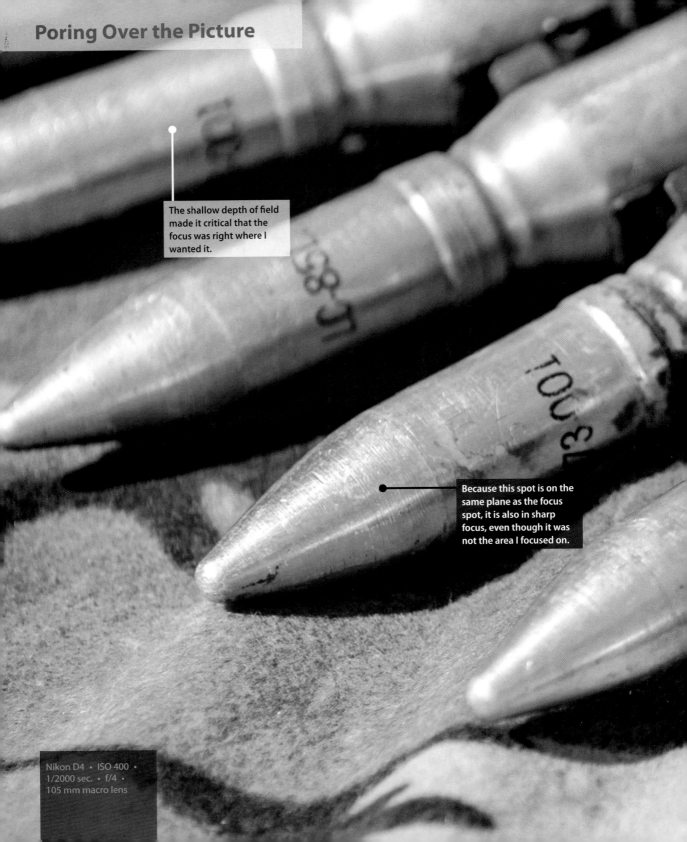

Poring Over the Picture

The shallow depth of field made it critical that the focus was right where I wanted it.

Because this spot is on the same plane as the focus spot, it is also in sharp focus, even though it was not the area I focused on.

Nikon D4 · ISO 400 ·
1/2000 sec. · f/4 ·
105 mm macro lens

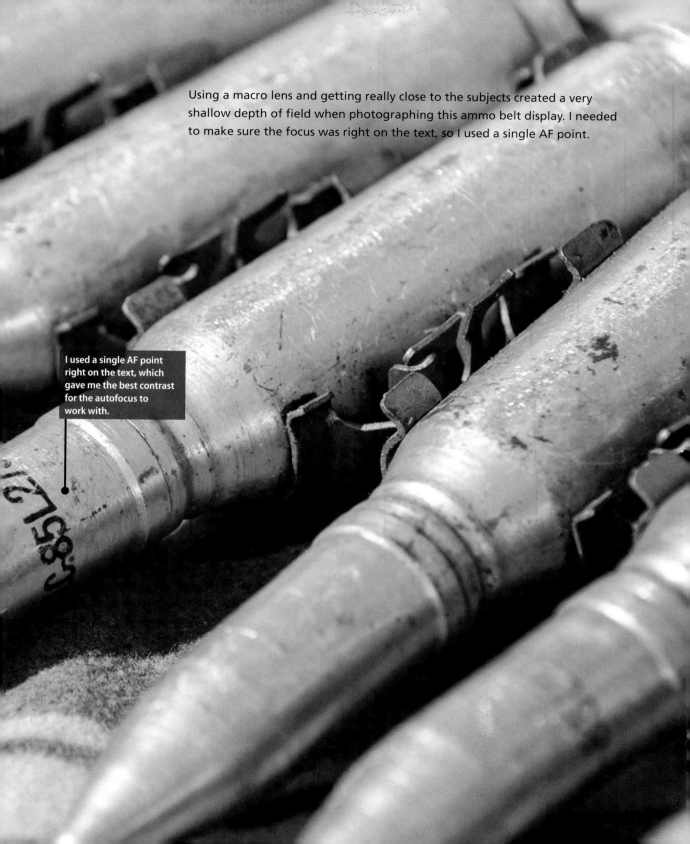

Using a macro lens and getting really close to the subjects created a very shallow depth of field when photographing this ammo belt display. I needed to make sure the focus was right on the text, so I used a single AF point.

I used a single AF point right on the text, which gave me the best contrast for the autofocus to work with.

Single Point AF Area Mode

In Single Point mode, the camera uses just a single AF point. This mode can be really accurate, as you get to determine exactly which of the autofocus points to use. This autofocus area mode is designed for both stationary subjects and moving subjects.

For portraits, I need to make sure that the focus is right on the subject's eye, so I use Single Point mode. In **Figure 5.1**, you can see that the focus point in the D750 was right over the subject's eye, not only using the information to focus, but also making sure that the eye is in sharp focus.

Figure 5.1
The focus point is directly over Sam's eye, ensuring that it is in sharp focus.

Nikon D750 ·
ISO 800 · 1/8 sec. ·
f/5.0 · 70–200mm lens

Using a single point as the spot on which to autofocus can make it tough for the camera to focus. When you need to make sure that the focus is on the subject and not the background, however, then single point is the way to go. For example, when taking macro photographs, a tiny shift in where the camera is focusing can make all the difference. In **Figure 5.2**, you can see the single AF point is on the back and head of the fly. If the focus point was moved just slightly or was bigger, then you'd be at risk for the camera focusing on the petal and not on the fly.

When I photograph concerts, I often use the single point to make sure that the focus is on the subject and not the microphone or guitar. The autofocus tries to focus on what's closest to the camera; so if you have a musician with a guitar and the autofocus point hits the guitar, the focus will be pulled from the performer. Using a single point can help you keep the focus right on the subject. In **Figure 5.3**, I made sure that the focus point was right on the musician's face and not on the guitar neck.

Of all the autofocus area modes, I use Single Point most often, because I like to have total control over what the camera focuses on. The reality is, however, that there are times this mode doesn't do the best job. Sometimes I need to use the dynamic autofocus modes, where the camera uses more than one of the autofocus points.

Figure 5.2
When taking this macro photograph, I placed the single focus point right over the head of the fly to make sure it was in focus and not the background.
Nikon D810 · ISO 800 · 1/250 sec. · f/8.0 · 105mm lens

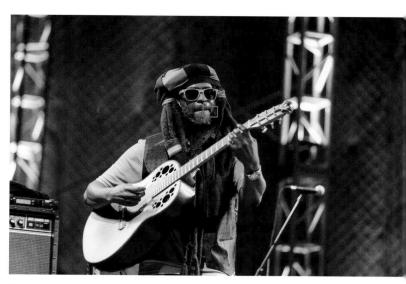

Figure 5.3
The guitar neck is closer to the camera than the musician, so if a focus point was not on the face, the guitar would have been in focus instead of the musician.
Nikon D4 · ISO 2000 · 1/250 sec. · f/2.8 · 70–200mm lens

Dynamic AF Area Mode

In Dynamic mode, you get to pick some or all of the autofocus points to help the camera focus. In this AF area mode, the camera still uses the single, selected AF point, but then uses the information from the surrounding AF points to help that original point focus.

The number of AF points that you can use depends on your camera's make and model. For example, on the Nikon D4 you can use a single point, 9 points, 21 points, or all 51 points. You can see the 9 AF points on the D750 in **Figure 5.4**. The center point is the one I chose, and the red dots mark the other points that are helping.

The more focus points you use, the more information the camera has to work with, but there is more of a chance that the focus will shift from what you want to focus on to something else.

You can see that some of the 9 AF points are on the background, but the majority of the points are on the surfer, helping out the selected AF point. These modes are designed for moving subjects and when it is more difficult to keep the camera locked onto the subject using the single AF point.

On the Canon 7D Mark II, two modes use a center AF point and then some of the points surrounding it: AF Point Expansion (4) uses a center point and 4 surrounding points, while AF Point Expansion (8) uses a center point and 8 surrounding points. For example, I selected the AF point (shown in red) right on the runner's number in **Figure 5.5**, then the camera also used the 4 surrounding AF points (shown in yellow) to help the AF track the subject.

Figure 5.4
Here is what the 9-point AF area looks like through the viewfinder of the D750. The active AF point is in the center, with the surrounding points adding information for the autofocus to use.

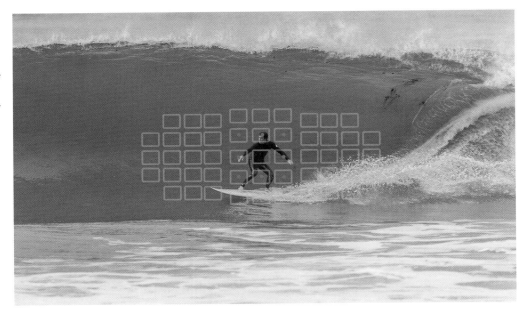

Figure 5.5

AF Point Expansion
(4) mode on the
Canon 7D Mark II
uses 5 AF points to
track the subject.
The main AF point is
shown in red, while
the 4 extra points
are shown in yellow.

Canon 7D Mark II ·
ISO 400 · 1/4000 sec. ·
f/2.8 · 70–200mm lens

If you are photographing a subject that is flat or mostly flat, the number of AF points doesn't really matter because everything is on the same plane or close enough. For example, I photographed part of a sign in **Figure 5.6** because I really liked the color and texture. The challenge was that the solid colors didn't give the camera much information to work with using a single point. Instead of moving that point around trying to find the best spot, I just turned on all the AF points and let the camera pick the ones to use.

Figure 5.6
Using all the focus points allowed the camera to pick the best ones. Because the subject was flat, it didn't matter which points were used. You can see all 51 points overlaid in red.

Nikon D750 · ISO 400 · 1/60 sec. · f/5.6 · 24–70mm lens

Auto Area AF Mode

In Auto Area mode, the camera uses all the autofocus points and picks a main focus point without any input from the photographer. If you are photographing a subject other than a person, the camera will tend to pick the things closest to the camera. When you photograph people, many of the newer cameras now use facial recognition to try to focus on the people. If there are multiple faces, the camera then tries to focus on the closest person. This technology is quite amazing, but it does give control to the camera over the wishes of the photographer.

This is not a mode that I use very often, because it usually doesn't give the results that I want. I believe that this is the mode that many photographers use and then get results that they didn't expect or want. It does, however, work great for landscapes, such as the sunset in **Figure 5.7**, where it didn't matter which of the 51 AF points was used.

In **Figures 5.8** and **5.9**, you can see how the camera picked two different focus points to change the very subject of the image. I didn't change any of the settings, but the camera switched between the tiki head in the background (Figure 5.8) and the flower in the front (Figure 5.9).

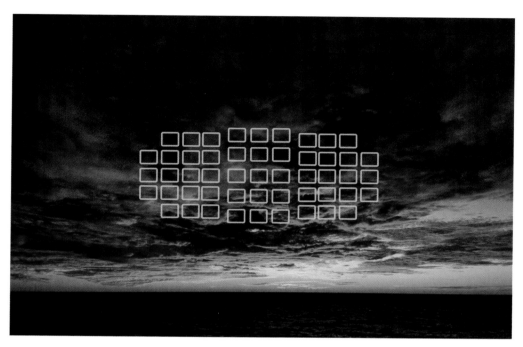

Figure 5.7
I photographed this sunset from the deck of cruise ship, where it didn't matter which of the focus points were used.

Nikon D750 •
ISO 400 • 1/60 sec. •
f/5.6 • 20–35mm lens

Figure 5.8 (left)
The camera picked the tiki in the background as the main subject.

Nikon D750 •
ISO 200 • 1/200 sec. •
f/3.2 • 105mm lens

Figure 5.9 (right)
The camera switched the focus point to the flower in the foreground without any input from the photographer.

Nikon D750 •
ISO 200 • 1/200 sec. •
f/3.2 • 105mm lens

If you have upgraded from a point-and-shoot camera or are just new to using a DSLR, then the Auto Area autofocus mode is a fine place to start. As you learn to use your camera, however, start to use the modes that give you control over what the camera focuses on. I think of this as "snapshot mode"; although it might work great in some instances, sooner or later, it will focus on something other than what you intended.

The Canon 7D Mark II offers an automatic selection with 65 autofocus points that gives control of the focus point over to the camera. In this mode, the camera takes control of the focus point but in one of two different ways, depending on the focus mode used. In One Shot mode, the camera just selects the closest subject (**Figure 5.10**), but in AI Servo mode, the photographer picks the starting point and then the camera tries to keep the subject in focus as it or the photographer moves. This is better than just leaving the choice up to the camera, but it can still have unwanted results. The camera needs to track the subject and can be fooled, especially if something comes between the subject and the camera (**Figure 5.11**).

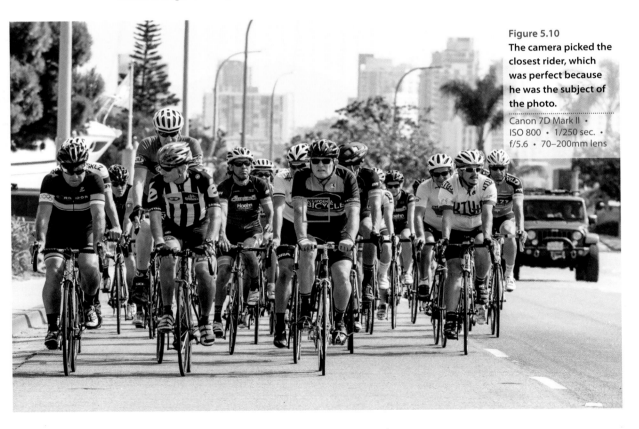

Figure 5.10
The camera picked the closest rider, which was perfect because he was the subject of the photo.
Canon 7D Mark II • ISO 800 • 1/250 sec. • f/5.6 • 70–200mm lens

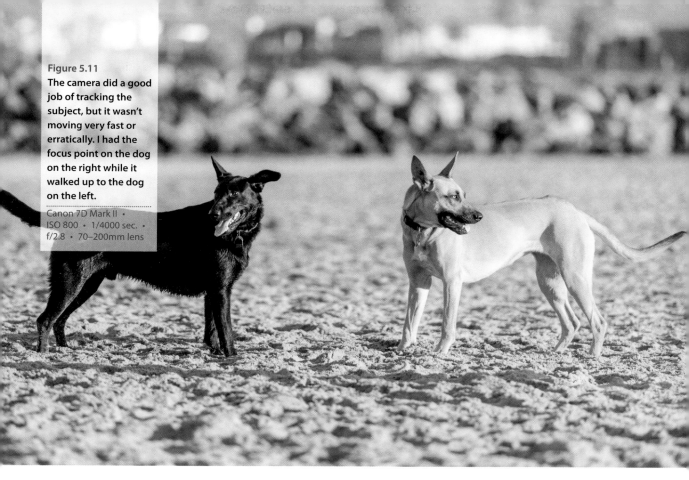

Group Area AF Mode

In Group mode, the camera uses multiple autofocus points as a group, giving each of the focus points equal weight in focusing. You still move the selected focus points around as you would when using a single point, but the surrounding points are just as active.

Currently, the Nikon system has only a single Group AF mode, which ties 5 of the AF points together to track the subject, as shown in **Figure 5.12**. I have begun to use this mode more and more when shooting fast-moving sports, such as hockey or soccer, as it delivers better results than the single-point and 9-point modes.

Canon cameras offer Zone AF area mode, for which 15 AF points are used together and the selected AF points automatically lock on the closest subject. Large Zone AF area mode divides the points into three sections (**Figure 5.13**) with each zone in a different color.

Figure 5.12
The AF points in the group (shown in red) were all used equally by the AF system, giving me better results. As you can see, if I had used a single point on the yellow shirt, there would not have been enough information. The group of points, however, also caught the logo, which increased the contrast and kept the focus locked.

Nikon D750 •
ISO 6400 • 1/800 sec. •
f/2.8 • 70–200mm lens

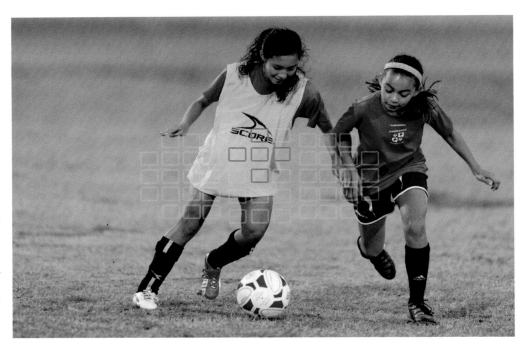

Figure 5.13
Each of the three areas is in a different color. This mode basically divides the camera AF area into thirds, and then picks the item closest to the camera out of those selected AF points.

Chapter 5 Assignments

Practice Changing the AF Area Modes

Being able to change the autofocus area mode quickly will let you capture the scene as you want to. To do this, you need to learn the controls required to change the AF area mode on your camera by reading the camera manual or one of the *Snapshots to Great Shots* books for your specific camera.

Try Different AF Area Modes

The quickest way to get good using the different modes is to try them out using the same subject. Pick a subject, and start by taking a photo using the Auto Area mode, letting the camera pick the focus point, then change the AF mode to one using a group, and finally to Single Point mode. See the difference in what you wanted to focus on compared to what the camera actually focused on.

Experiment with Fast-Moving Subjects

Picking the right autofocus area mode when shooting sports and action is part science and part personal preference. The only way you are going to know what mode to use is to try them out on moving subjects. I suggest going to a dog park or local running spot and try the different modes to see which one gives you the best results.

Share you results with the book's Flickr group!
Join the group here: flickr.com/groups/focusandautofocus_fromsnapshotstogreatshots

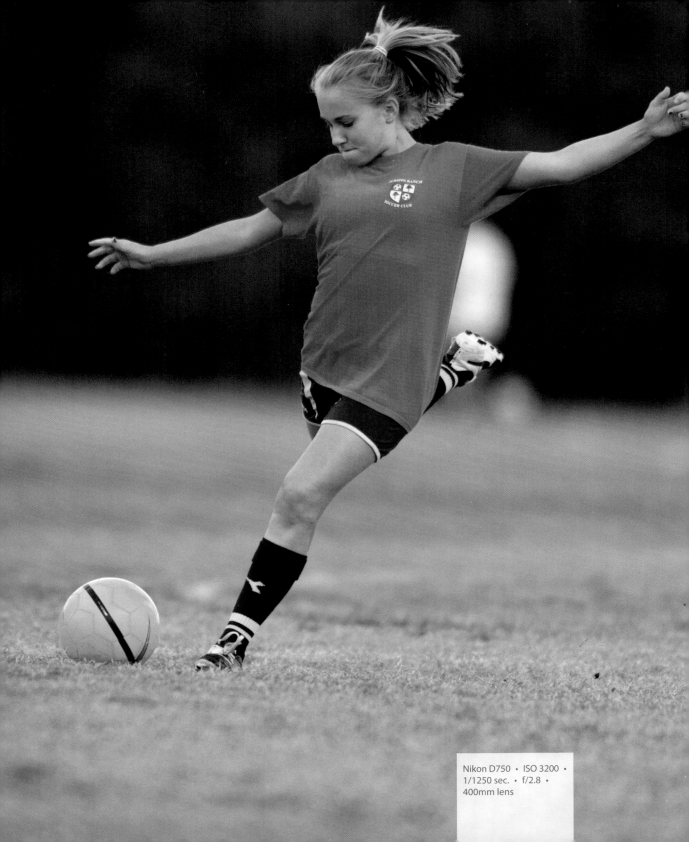

Nikon D750 • ISO 3200 •
1/1250 sec. • f/2.8 •
400mm lens

6
Common Autofocus Issues and How to Fix Them

Solutions for getting the autofocus to work in difficult situations

The autofocus ability of DLSRs is outstanding and camera manufacturers are improving on it with every new camera generation. But outstanding isn't the same as perfect. Autofocus can have issues, and in some situations be more frustrating than helpful. When out making photographs in difficult circumstances, however, you can avoid the headaches and help the autofocus do its job by following a few simple practices. This chapter covers how to deal with low-contrast scenes and shooting in low light, along with how to increase the odds that the autofocus will work properly when shooting through fences and glass. You'll also learn about pre-focusing for fast-moving subjects and fine-tuning the autofocus.

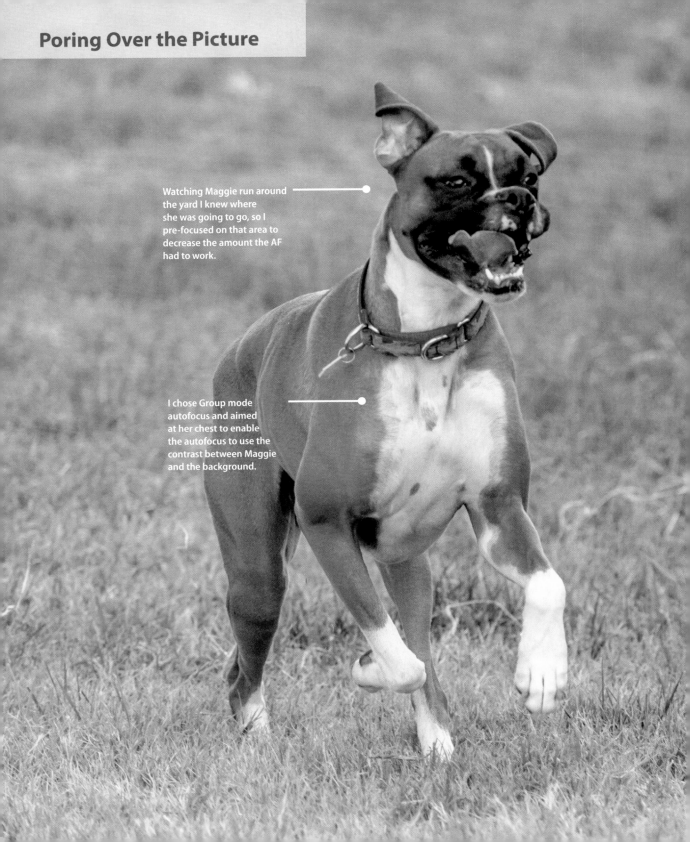

Poring Over the Picture

Watching Maggie run around the yard I knew where she was going to go, so I pre-focused on that area to decrease the amount the AF had to work.

I chose Group mode autofocus and aimed at her chest to enable the autofocus to use the contrast between Maggie and the background.

A shallow depth of field creates a blurred background and helps the subject to pop from the background.

Photographing Maggie running through the yard looks easier than it really is. Her white chest is tough for the autofocus to lock onto, so I use multiple AF points and try to shoot at an angle that creates contrast between her and the background.

Nikon D750 · ISO 400 · 1/4000 sec. · f/5.6 · 80–400mm f/4.5-5.6 lens

Poring Over the Picture

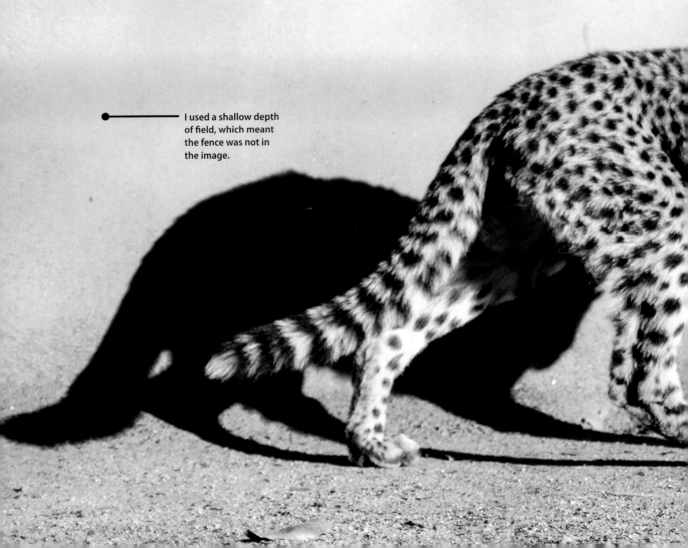

This photo was taken through the very thick fence;
but as you can see, there is no sign of the fence in
the photo due to the shallow depth of field and
position of the cat.

I used a shallow depth
of field, which meant
the fence was not in
the image.

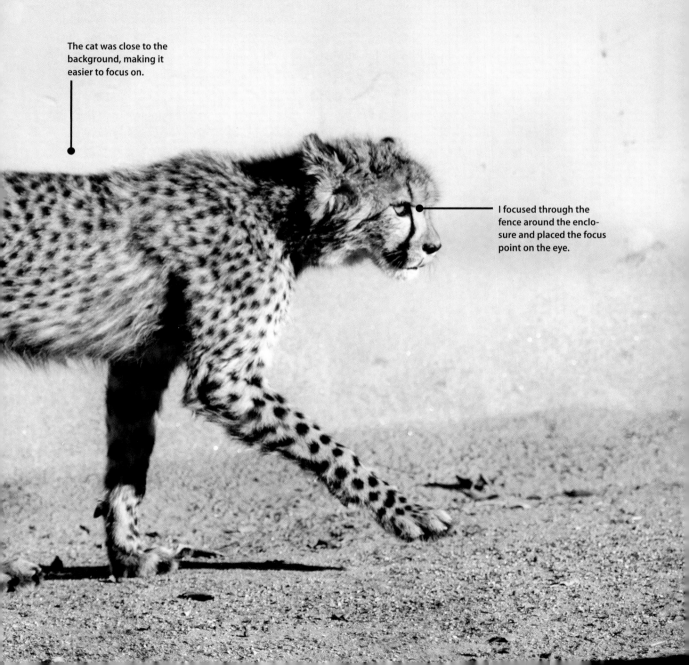

Nikon D4 • ISO 400 •
1/2000 sec. • f/2.8 •
70–200mm lens

The cat was close to the
background, making it
easier to focus on.

I focused through the
fence around the enclo-
sure and placed the focus
point on the eye.

Low Contrast

Autofocus has the biggest problems when the area you are photographing lacks contrast. As discussed back in Chapter 2, there are two types of autofocus technologies at work in your camera: phase detection and contrast detection. Both of these technologies use contrast to autofocus, so you need to be sure that the area under the selected AF point (or points) has enough contrast for the autofocus to look at. With today's cameras offering the choice of so many focus points, you can easily become so wrapped up in composing the image that you don't notice your single point ends up placed over an area of the image that has very little or no contrast. The solution is to use more of those available points: Increase the number of autofocus points being used to give the camera more information to work with.

For example, the single AF point over the black shirt in **Figure 6.1** does not give the camera enough contrast to focus on, so using 9-point autofocus covers a bigger area and gives the camera more information to use, including the contrast between the shirt and the neck (**Figure 6.2**).

Figure 6.1 (left)
The single AF point is right over the shirt, which is not giving the camera a lot to work with.

Nikon D750 ·
ISO 200 · 1/250 sec. ·
f/6.3 · 70–200mm lens

Figure 6.2 (right)
Using the 9-point AF mode gives the camera more information to work with, including the contrast between the shirt and the neck.

Nikon D750 ·
ISO 200 · 1/250 sec. ·
f/6.3 · 70–200mm lens

Another solution is to pick another point and focus on something else that is the exact same distance from what you want to be in focus. Because everything in the same plane will be in focus, anything that is the same distance from the camera will be in focus. This technique works really well if what you are photographing is stationary, but it is much more difficult if the subject is moving.

In **Figure 6.3**, you can see that the two toys are the same distance from the camera. You can focus on the one that has more contrast, and both toys will be in focus.

A variation of this technique is to focus on something outside of the frame, then to recompose the scene after the focus is locked. This works in single-subject AF only because the camera needs to stop trying to focus after the focus is locked. All you do is pick something the same distance from the subject, place the AF point over it, and press the shutter release button down until the focus is locked. Then, without removing your finger from the shutter release button, recompose the photo, and finally take the photograph. In **Figure 6.4**, I focused on the edge of a chair that was set up at the same distance as the stuffed animal.

Figure 6.3
Picking the toy with more contrast allows the AF to work, but the two items need to be the same distance from the camera.

Nikon D750 · ISO 800 · 1/250 sec. · f/2.8 · 24–70mm lens

Figure 6.4
The focus was taken using a chair that was out of the frame to the left, then I just recomposed and took the photo.

Nikon D750 · ISO 800 · 1/100 sec. · f/3.0 · 105mm lens

Low Light

The autofocus module reads the light coming in through the lens, so you need light for the sensor to actually work. There are two things at work here: the amount of light in the actual scene and the widest maximum aperture that the lens can open. When photographing in very low light, you have two options to try if the autofocus is not locking onto the subject. The first is to add more light, and the second is to use a faster lens. For **Figure 6.5**, I needed to add some light to allow the autofocus to see the dark karate gi worn by Sensei Sanchez.

Figure 6.5
I needed to add more light to the scene so the camera would lock the focus on the dark karate gi in the dark studio.

Nikon D4 · ISO 100 · 1/250 sec. · f/6.3 · 24–70mm lens

Most consumer-level and intermediate DSLRs have a small light built right into the camera body that can be turned on to help the camera focus. You can see the autofocus-assist lamp on the front of the Nikon D3200 in **Figure 6.6**. This light tries to illuminate the subject when the camera thinks it's too dark, but you need to make sure that the feature is turned on. Read your camera manual to find out where to turn the autofocus-assist lamp on and off, and turn it on when shooting in very low light. You can see the menu choice in the Sony A7II in **Figure 6.7**.

When the autofocus-assist lamp is turned on, the light comes on as you press the shutter release button down and activate the autofocus in low light. The limitation to this is that the lamp has a limited range and is useful only at pretty close range.

For **Figure 6.8**, I used the autofocus-assist lamp to help the focus when taking photos at the local Day of the Dead celebration. The sun had set, and the streetlights hadn't come on yet. In that very low light, the focus was having issues locking onto the subject. The downside to the autofocus-assist beam is that it can be distracting to the subject, just as shining a flashlight into someone's face can be distracting. I keep the lamp turned off until I really need it.

Figure 6.6
The autofocus-assist lamp on the front of the Nikon D3200 adds some light when the camera needs to focus in very low light.

Figure 6.7
This menu allows you to turn the autofocus-assist lamp on and off.

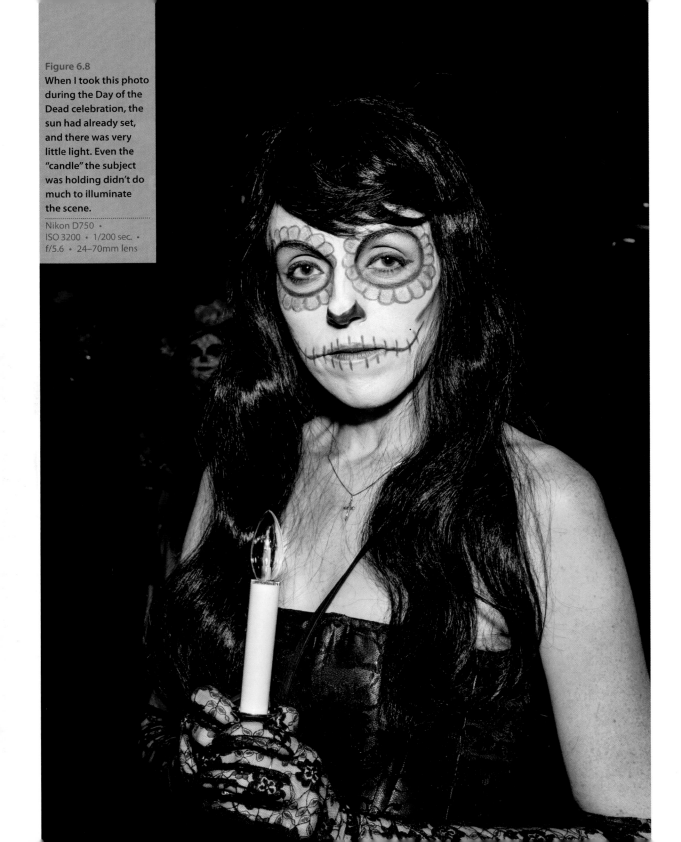

Figure 6.8
When I took this photo during the Day of the Dead celebration, the sun had already set, and there was very little light. Even the "candle" the subject was holding didn't do much to illuminate the scene.

Nikon D750 •
ISO 3200 • 1/200 sec. •
f/5.6 • 24–70mm lens

The second option is to use a lens with a wider maximum aperture, so that the autofocus module has more information to work with, and to use the center focus point, which usually is designed to be the most accurate with lenses that open up to f/2.8. This works better for action photos where the autofocus-assist beam will not reach the subject or will be a distraction.

Many of the concerts I shoot take place in dimly lit venues that result in autofocus issues, especially with the faster-moving subjects. Using a fast glass, a lens with a very wide maximum aperture that opens to f/2.8, gives me an edge and helps the autofocus work better. In **Figure 6.9**, the combination of a lens that opened to f/2.8 and my waiting for the performer to move into the brightest spot on stage allowed the autofocus to lock onto the subject.

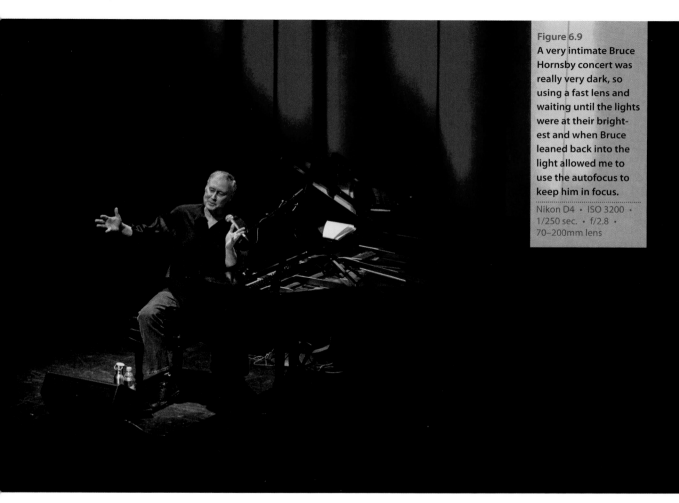

Figure 6.9
A very intimate Bruce Hornsby concert was really very dark, so using a fast lens and waiting until the lights were at their brightest and when Bruce leaned back into the light allowed me to use the autofocus to keep him in focus.

Nikon D4 · ISO 3200 · 1/250 sec. · f/2.8 · 70–200mm lens

Glass and Other Obstacles

One of the difficult tasks for autofocus is when you need to photograph through glass or a fence. The camera will try to focus on the object closest to the camera, which is the glass or fence rather than the subject of the photo. If your photos usually end up looking like **Figure 6.10**, don't worry. There are a few things that you can do to help the autofocus properly focus on the subject you want, so soon you'll be capturing photos like **Figure 6.11** instead.

The first thing that you need to do is get as close to the fence or glass as possible. Because every lens has a minimum focusing distance, you want to get closer to the fence or glass than the minimum focusing distance. This means that the camera can't focus on the fence or glass. The second thing to do is to use as shallow a depth of field as possible so that the subject on the other side of the barrier is in sharp focus but nothing in front (like the barrier) or behind is in sharp focus. The third thing you can do is to turn on the distance-limiting feature of the lens, if it has one. This limits the distance range that the lens will work at, so it will ignore the fence in front of the lens and instead try to focus at the subject on the other side.

The final piece of the puzzle is to wait until the subject is back from the fence so that there is a good amount of distance between the barrier and the subject, allowing for really great photos that don't look like they were shot through a fence, such as the lioness in **Figure 6.12**.

Figure 6.10
When photographing through an obstacle like a fence or a window, the camera will keep trying to focus on the subject that is closest to the camera, which can be the window or the fence, as seen here.

Nikon D4 · ISO 400 · 1/4000 sec. · f/2.8 · 70–200mm lens

Figure 6.11
Getting really close and focusing through the fence allows me to capture the subject and not the barrier.

Nikon D4 · ISO 400 · 1/4000 sec. · f/2.8 · 70–200mm lens

Figure 6.12
Photographed through a very secure fence, this lion was at the far end of the enclosure, making it easier to get a tack-sharp photo.

Nikon D4 · ISO 1600 · 1/5000 sec. · f/2.8 · 70–200mm lens

Fast-Moving Subjects

I photograph quite a lot of sports and have recently started to photograph hockey, which has some very fast movement and the autofocus doesn't always keep up. What ends up happening is that I get photographs of the players not involved in the action or a photo of the referee.

There are three things that I do to help the autofocus work better when shooting sports and action. The first is to use the back-button autofocus that I discussed in Chapter 1. The second is to figure out where the action is going to take place and pre-focus so that the camera doesn't have to work very hard when the action does happen. For **Figure 6.13**, for example, I focused on the goalie and started to shoot as I saw her move to catch the ball. I did not try to focus on the ball, as it was moving too fast for me to keep in the frame.

The third thing that I do to help the autofocus is try to minimize the background so that there is more contrast for the autofocus to use. This gives the camera more information to work with, which allows the autofocus to work faster and, hopefully, keep a lock on the subject. For example, when I started to photograph hockey, I found it easier to shoot at a downward angle, which created a lot of contrast between the players and the ice (**Figure 6.14**).

Figure 6.13 (left)
I kept the focus right on the face of the goalie and took a series of photos as she started to move. Knowing that the goal was the target made it easier to capture this photograph.
Nikon D4 · ISO 800 · 1/3200 sec. · f/2.8 · 70–200mm lens

Figure 6.14 (right)
The contrast between the black gloves, the hockey stick, and the ice helped the autofocus keep track of the player.
Nikon D750 · ISO 3200 · 1/800 sec. · f/2.8 · 70–200mm lens

Combating Shutter Lag

One of the most common causes of blurry photos is the time between pushing the shutter release button and the actual photo being taken. This shutter lag is usually present in the low-end consumer cameras and point-and-shoot cameras, and is a common problem when photographing kids and pets that move exactly when the photo is being taken. The fix is pretty simple, and it can help any photographer who is having issues with a subject moving right as the photo is being taken.

The key is to use continuous autofocus even if the subjects are sitting still. Make sure that you press the shutter release button halfway down to activate the autofocus, then wait a second so that the autofocus can lock onto the subject and stay locked on the subject as you press the shutter release button. This is how I shoot the portraits of my dogs, because chances are good that they are going to move at the worst possible moment, creating a blurred image instead of a sharp one. For **Figure 6.15**, I pressed the shutter release button halfway down to activate the autofocus when Maggie was still sitting down. She promptly stood up, but because the autofocus was already locked on, I still got a sharp, in-focus photo.

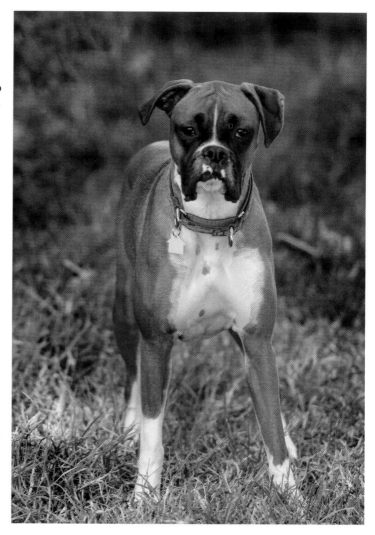

Figure 6.15
I started to take a photo of Maggie, our Boxer, while she was sitting, but she jumped up before I could press the shutter release button all the way down. Continuous autofocus mode, and making sure I activated the autofocus as soon as possible, made this photo possible.

Nikon D750 · ISO 400 · 1/1000 sec. · f/2.8 · 70–200mm lens

Using the continuous autofocus really makes a difference and helps you get the images in focus even when the subject might move unexpectedly. For example, in **Figure 6.16**, when Olivia was playing on the rocks at the tide pools, I made sure that I used continuous autofocus to keep her in focus as she starts to channel her inner karate kid.

Fine-Tune the AF

Back in Chapter 1, I gave a couple of suggestions on testing the focus of your camera and lens, but there's more to discuss. Many cameras now allow you to make adjustments to the focus, and if you want to fine-tune the autofocus of your camera, you can.

One of the best tools for this is the Lens Align and FocusTune kit from Michael Tapes Design (http://michaeltapesdesign.com/store.html). I am not suggesting that everyone go out and get this tool as it does cost over $120, but if you are one of those folks with numerous lenses, whose camera supports the AF fine-tune feature, and who wants to make sure your focus is as accurate as possible, then this is the way to go. This product is a combination of a target that you photograph and software that analyses the resulting images to let you know exactly where to set the camera's AF fine-tuning adjustment (**Figures 6.17** and **6.18**).

If you find that you have a lens that seems to be way off, the best bet is to send it to the manufacturer to be repaired.

Figure 6.16
Making sure that the camera was set to continuous autofocus allowed me to get to the crane pose as it happened.

Nikon D750 • ISO 100 • 1/1250 sec. • f/2.8 • 70–200mm lens

Figure 6.17
You can see the camera set up on one tripod and the focus chart set up on a second.

Before After

Figure 6.18
Here is the difference between the lens before the adjustment and after.

Service the Camera and Lens

There are times when the autofocus doesn't seem to work properly even in great light with a subject that has plenty of contrast. Because digital cameras and their lenses are finely tuned, it is possible for something to have gone wrong inside the camera or lens. It is also possible to have impact damage to the lenses that causes the focusing mechanism to malfunction. In these cases, it is best to send the camera and any affected lenses back to the camera manufacturer for a cleaning and repair.

Before you ship your gear off, there are a few things that you can try at home first. Even if you have to send the camera in for repair eventually, the information you get from these steps will help the technicians fix it:

- **Clean the contacts in the lens.** The small metal contacts on the lens allow the camera to communicate with the lens, so make sure that they are clean (**Figure 6.19**). Wipe with a lint-free dry cloth to remove any dirt or grime.

- **Clean the contacts in the camera.** Check to see that the contacts in the camera where the lens connects are clean (**Figure 6.20**). No point in cleaning off the contacts in the lens if the ones in the camera are dirty.

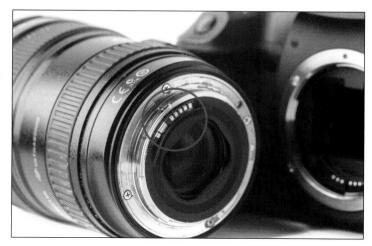

Figure 6.19
The contacts on the lens need to be clean so that the camera and lens can talk to each other.

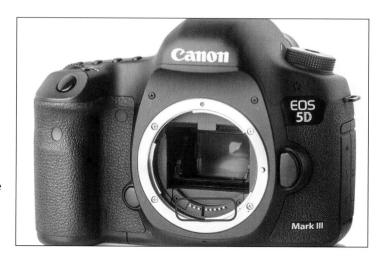

Figure 6.20
The contacts in the camera match up with the contacts in the lens so that the camera and lens can communicate.

- **Make sure the autofocus is turned on.** This is the one thing that still catches me on a regular basis. Make sure that the autofocus is turned on. Remember that some cameras have the AF/M switch on the body and some on the lens—and some have both.

- **Determine if the autofocus problem happens with all lenses.** You can help narrow down the issue by checking if the autofocus issue happens with all lenses attached to the camera or just one lens. If it happens with all the lenses, then the issue is most likely the camera. If it just happens with a single lens, then it is probably the lens.

- **Determine if the problem happens with all autofocus modes.** One last thing that you can do to see what the issue might be is to change the autofocus mode of the camera. If doing so helps, you can still use the camera, but it needs to be checked out by the camera manufacturer. If none of the autofocus modes work, you will need to get the camera repaired (or replaced).

If you need to send your camera and lenses to the manufacturer to get repaired, you can find the information on the Internet. For Nikon cameras, a good place to start is www.nikonusa.com/en/service-and-support/service-and-repair.page. There you can schedule a repair or find an authorized repair provider.

For the Canon photographers, the best starting point is www.usa.canon.com/repair, and for Sony, just start at https://eservice.sony.com/webrma/web/index.do.

You do have options and can go to an independent camera repair facility like Kurt's Camera Repair (http://kurtscamerarepair.com). The shop is located in San Diego but takes repairs from anywhere.

One last thing to keep in mind when repairing a digital camera, especially an older model or a lower-end consumer camera: The repair might be more expensive than just replacing the camera, so check out the camera prices on a comparable model before spending a lot to have yours repaired.

If you are a professional photographer who needs to make sure that your gear works all the time, consider having your camera and lenses serviced on a regular basis. This will usually be a lot less expensive and can nip any issues before they become major problems.

Chapter 6 Assignments

Practice Looking for Alternative Focus Areas

When shooting a subject that has low contrast, start looking for other items that are the same distance from the camera as the subject. You can use these alternative subjects as something to focus on, and then recompose the photo. It is also worth trying different focus areas to see if using more focus points will help the autofocus lock onto the subject.

Try Using the AF-Assist Light

Learn how to turn the autofocus-assist light on and off before you actually need it. You can do this in your living room any evening by just turning off some of the lights until it is dark enough for the autofocus to need help, then turn on the AF-assist light and try to take the same photo. If you want to take it a step further, try using it outside to see how far it actually works.

Practice Picking a Spot to Pre-focus On

When shooting a sport or action where the action takes place in a controlled area, find a spot to focus on and wait for the action to come to you. Sometimes you need to take the camera down from your face and watch the action to figure out the best place to focus on.

Share you results with the book's Flickr group!
Join the group here: flickr.com/groups/focusandautofocus_fromsnapshotstogreatshots

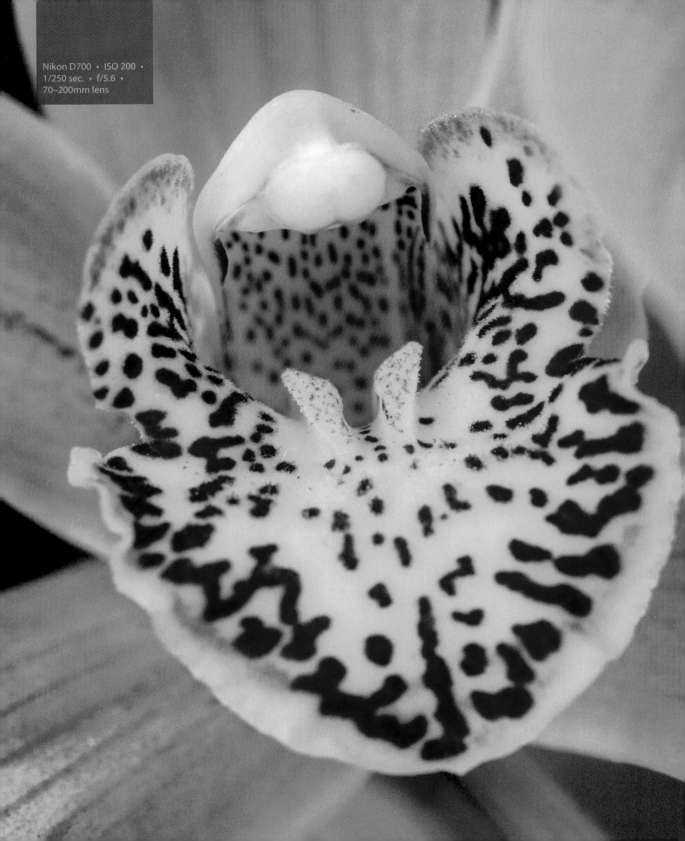

Nikon D700 · ISO 200 ·
1/250 sec. · f/5.6 ·
70–200mm lens

7
Manual Focus

When it's best to go manual

When I first picked up a camera many, many years ago, there was no autofocus. It was incredibly frustrating trying to manually focus, especially on fast-moving subjects, but there was no other choice. I had plenty of out-of-focus shots before the practice started to pay off and I could manually focus pretty well. Even with today's autofocus options, manual focusing is a valuable skill to learn. Although just letting the camera take care of the focusing is easier, being able to manually focus can help in situations where the autofocus doesn't work or struggles to achieve focus.

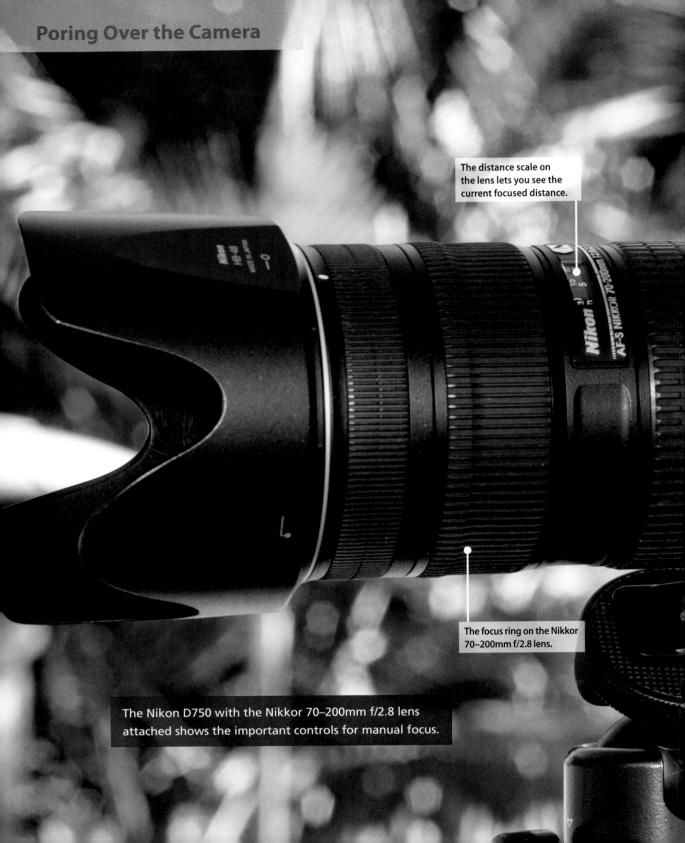

The distance scale on the lens lets you see the current focused distance.

The focus ring on the Nikkor 70–200mm f/2.8 lens.

The Nikon D750 with the Nikkor 70–200mm f/2.8 lens attached shows the important controls for manual focus.

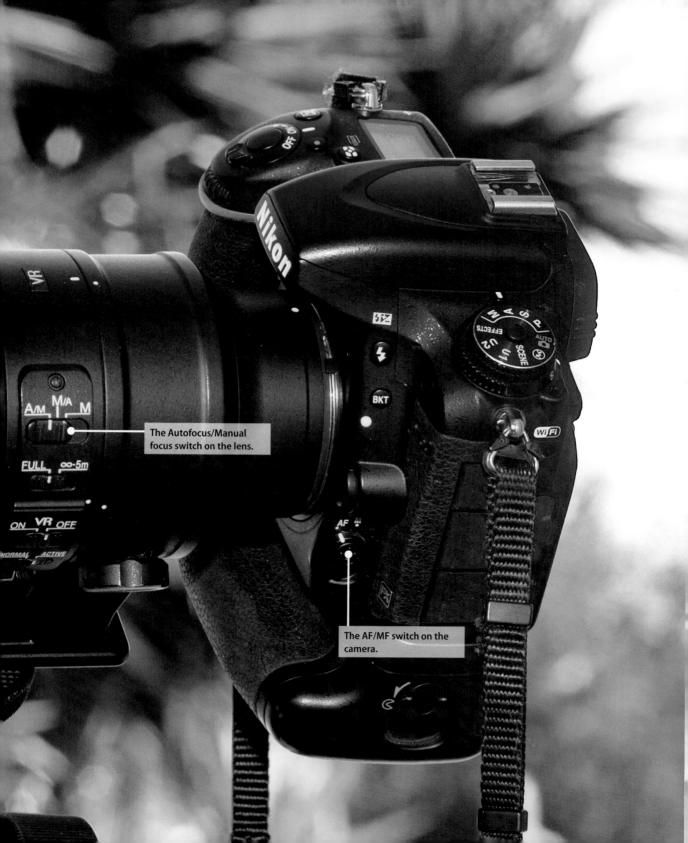

The Autofocus/Manual focus switch on the lens.

The AF/MF switch on the camera.

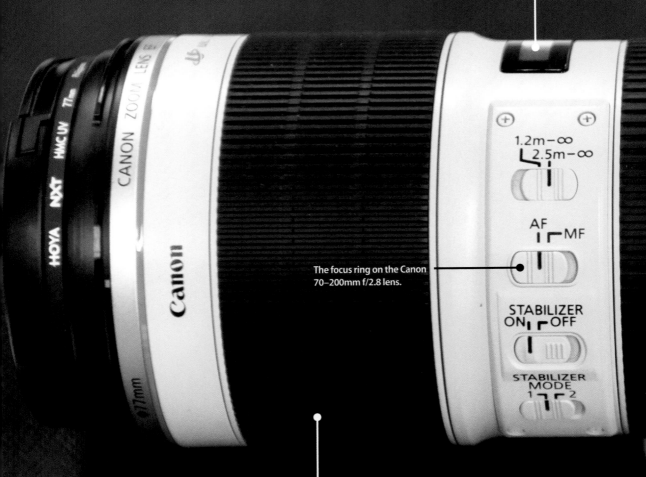

The distance scale on the lens lets you see the current focused distance.

The focus ring on the Canon 70–200mm f/2.8 lens.

The focus ring on the Canon 70–200mm f/2.8 lens.

The Canon EOS 70D with the 70–200mm f/2.8 lens
attached shows the important manual focus controls.

Figure 7.1
The diopter adjustment on the Nikon D750 is located right next to the viewfinder.

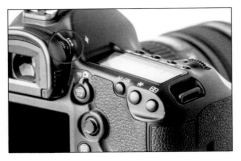

Figure 7.2
The diopter adjustment on the Canon 5D Mark III is located on the top-right of the viewfinder.

Diopter Adjustment

When discussing manual focus, the very first thing that needs to be addressed is the diopter adjustment. Available on most DSLRs, the *diopter adjustment* allows you to adjust the view through the viewfinder to match your eyesight. Getting this right is extremely important, because with manual focus you need to use your eyesight to decide when the subject is in focus.

The diopter adjustment does not affect the autofocus or focus of the camera at all; it affects only how well you see through the viewfinder. The diopter adjustment is usually made by turning a small wheel or knob located right by the viewfinder, as shown in **Figure 7.1** on the Nikon D750 and in **Figure 7.2** on the Canon 5D Mark III.

Adjusting the diopter is pretty easy and takes only a couple of seconds, but it can make a world of difference. Just follow these steps to adjust the diopter on your camera:

1. Mount a lens on the camera, and remove the lens cap.
2. Turn the camera on, and press the shutter release button halfway down.
3. Look through the viewfinder, but instead of paying attention to the scene, look at the display on the bottom of the viewfinder.
4. Rotate the diopter adjustment until the display is really blurry (**Figure 7.3**).
5. Rotate the diopter adjustment until the display becomes as sharp as possible (**Figure 7.4**).

That's it. The diopter is now adjusted to your eye.

Remember to periodically check to make sure that it is still adjusted to your eye, especially if someone else uses your camera. The diopter adjustment cannot be locked. If it gets moved, even a little bit, you will need to fix it.

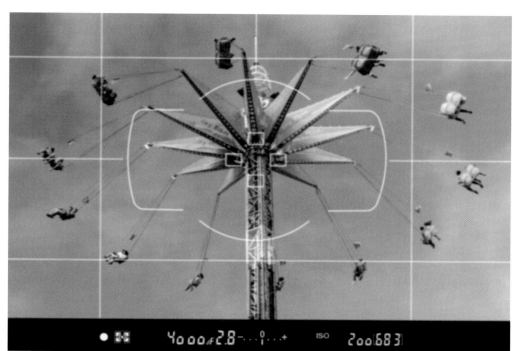

Figure 7.3
When the diopter is out of adjustment, everything in the viewfinder is out of focus.

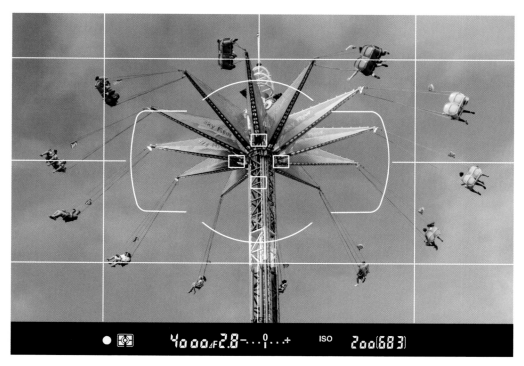

Figure 7.4
When the diopter is properly adjusted, everything in the viewfinder is in sharp focus.

What Is Manual Focus?

Manual focus is when you, the photographer, turn the focusing ring on the lens barrel to focus the light coming in through the lens so that the image is in focus on the camera's sensor. When the camera and lens are set to manual focus, the camera turns off the autofocus. Now when you press the shutter release button all the way down, the camera moves the shutter out of the way and creates a photo. That photo will be blurry unless you focus the lens before pressing the shutter release.

Figure 7.5
Turn the focusing ring on the Nikon to the left to bring near objects into focus.

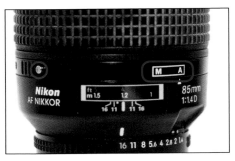

Figure 7.6
The Nikkor 85mm f/2.4 lens has a locking Manual/ Autofocus switch around the lens barrel. You press the silver button in, then rotate the switch.

To manually focus a lens, turn the focusing ring (**Figure 7.5**) until the subject is in focus through the viewfinder or, if you are using Live View, on the LCD on the camera. The *direction* that you turn the ring depends on the brand of camera. Nikon and Canon work backwards from each other. On the Nikon system, you turn the focusing ring from left to right (clockwise) when holding the camera up to your eye to bring the objects farther from the camera into focus. When you rotate the lens from right to left (counterclockwise), you bring the closer objects into focus. On the Canon system, it works exactly the opposite: clockwise to focus on close objects and counterclockwise to focus farther-away objects.

Some lenses allow you to turn the focusing ring when the autofocus is engaged, but others lock the focusing ring unless the lens is set to manual focus. Do not force the focusing ring *ever*; doing so can damage the focusing mechanism in the lens. Some lenses, such as the older Nikkor 85mm f/1.4 shown in **Figure 7.6**, even have a locking mechanism that stops the lens from being inadvertently switched from autofocus to manual focus. You have to press the metal button in, then rotate the A/M switch. When the lens is locked in A (autofocus) mode, the focus ring will not turn.

The Camera Can Help

Just because you have turned off the autofocus, that doesn't actually mean the autofocus isn't looking at the scene and offering suggestions. When you look through the viewfinder, part of the display shows if the camera thinks the area under the selected AF point is in focus or not.

In Nikon cameras, on the bottom left of the viewfinder you'll find three very important icons: the left arrow, the circle, and the right arrow. Together these make up the in-focus indicator shown in **Figure 7.7**. When the camera believes that the focus is correct, the circle is lit. When the left arrow is lit, then the focus point is between the camera and the subject, and when the right arrow is lit, the focus point is behind the subject. If both arrows flash, then the camera can't focus. These indicators work with the autofocus, and they also continue to work when you manually focus, letting you know what the camera believes the focus should be. The big difference is that the camera doesn't do anything about it when you are in manual focus mode.

On the Canon 5D Mark III, the focus indicator is on the right side, with a slightly different-looking arrow icon, as shown in **Figure 7.8**.

Check out the camera manual for you specific camera to find out the location of the focus indicators and how they work for your camera model.

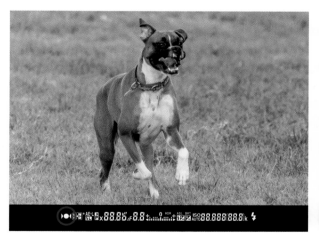

Figure 7.7
The view through the viewfinder of the Nikon D750 with the in-focus indicator next to the red arrow.

Figure 7.8
Notice the focus indicators on the right in this view through the viewfinder of the Canon 5D Mark III.

Lens Distance Scale

Many lenses (but not all) have a built-in distance scale that allows you to focus by setting the distance between the camera and the subject. For example, **Figure 7.9** shows the distance scale on the Nikkor 35mm f/2.0 lens with the distance set to 3 feet. This means that anything 3 feet away from the lens will be in focus.

Figure 7.9
The lens distance scale on the Nikkor 35mm lens has the focus set to 3 feet.

The lens distance scale can be a time-saver, because it allows you to quickly set the distance that the lens is looking at without even bringing the camera up to your eye. If you are taking a macro photograph, for instance, you can set the minimum focusing distance on the lens and then adjust the camera position to achieve focus, creating the closest possible image (more on this in the next section).

Not all lenses have this focusing scale. It is lacking from a lot of newer lenses aimed at the hobbyist photographer, probably due to the advances in autofocus and as a cost-saving measure. Although a lens distance scale is nice to have, it isn't critical.

When to Use Manual Focus

Back in Chapter 1, I listed some of the scenarios in which you would want to choose manual focus, including photographing things like firework displays, time-lapse photography, and macro photography. Now it is time to investigate these types of photography in more detail. Along the way, you'll learn the difference between using manual focus for things that the autofocus can't do and the times when you just don't want the camera to focus at all.

First, let's look at when to use manual focus because the autofocus doesn't work or does not focus properly. Improper focus can occur when the light is too low, there is not enough contrast, or the camera is just having a tough time focusing on the proper spot. This happens a lot when shooting macro photographs for which the focus needs to be exactly on the subject. In **Figure 7.10**, the autofocus looked for the subject, but kept focusing on the background. When I switched to manual focus, I was able to keep the focus on the subject and off the background (**Figure 7.11**). Macro photography is one of the most common places to use manual focus and is covered in more detail in Chapter 8.

When you want the camera to just take the photo without it making any focus adjustments, switch to manual focus. You usually want to turn off autofocus when shooting a

subject in an area that would cause difficulty for the autofocus and when waiting while the camera tries to achieve focus would mean missing the image. Subjects like fireworks and time-lapse images fall into this category, as mentioned in Chapter 1. Setting the camera on manual focus stops the camera from trying to autofocus when the shutter release button is pressed. When photographing fireworks, you need to start the exposure before the explosions so the camera doesn't have anything to focus on. Autofocusing on the first explosion allowed me to be ready for the subsequent exposures with the camera set to manual focus (**Figure 7.12**).

Another scenario that needs the focus set and then turned from autofocus to manual focus is when photographing splashes and drops, as shown in **Figure 7.13**. For these type of photos, I first pre-focus the camera right on the spot where the drop is going to happen, then I switch from autofocus to manual focus so that the camera won't try to refocus when the shutter release button is pressed. To pre-focus for the splashing berry, I floated a wooden clothespin as a substitute for the strawberry and focused on the clothespin (**Figure 7.14**). I then made sure the focus was set to manual focus. The key is to make sure that the point the camera is focused on is in the same area where the action is going to happen. Then it is all about the timing. I dropped the strawberry and pressed the shutter release button when the strawberry hit the milk.

Figure 7.12
I focused on the first firework explosion using the autofocus, then turned the autofocus off so that the camera wouldn't try to focus when I pressed the shutter release button down to photograph the next set of explosions.

Nikon D700 •
ISO 400 •
6 seconds • f/9 •
24–70mm f/2.8 lens

Figure 7.13 (left)
Here is the final strawberry drop photo. As you can see, the focus is right on the spot where I pre-focused using the floating clothespin in Figure 7.14.

Nikon D4 • ISO 1600 •
1/2000 sec. • f/7.1 •
24–70mm f/2.8 lens

Figure 7.14 (right)
I pre-focused the camera on the clothespin, which floated right in the spot where I planned to drop the strawberry.

Nikon D4 • ISO 1600 •
1/2000 sec. • f/7.1 •
24–70mm f/2.8 lens

Chapter 7 Assignments

Practice Setting the Diopter Adjustment

Locate the diopter adjustment on your camera, and make sure you know how to change it. Make sure that the view through your viewfinder is sharp and in focus so that when you use manual focus and the image looks sharp in the viewfinder, it is in focus.

Practice Switching Between Autofocus and Manual Focus

In some types of photography, you need to be able to switch between autofocus and manual focus without moving the camera at all. For photos of subjects like fireworks or splashes, you want the focus set and the camera locked in place. Knowing where the AM/MF switch is located and which direction to move it without looking is key.

Experiment with Manual Focus

Practice using manual focus before you need it. Set up your camera in a tripod and manually focus on any stationary subject, then check to see if the camera agrees with you by looking at the focus indicator through the viewfinder. Is the focus point over the subject in the same place you are focusing? Using the distance scale on the lens, does it match the actual distance of the subject from the lens? Knowing how these all work together will help when you need to use the manual focus in a critical situation.

Share you results with the book's Flickr group!
Join the group here: flickr.com/groups/focusandautofocus_fromsnapshotstogreatshots

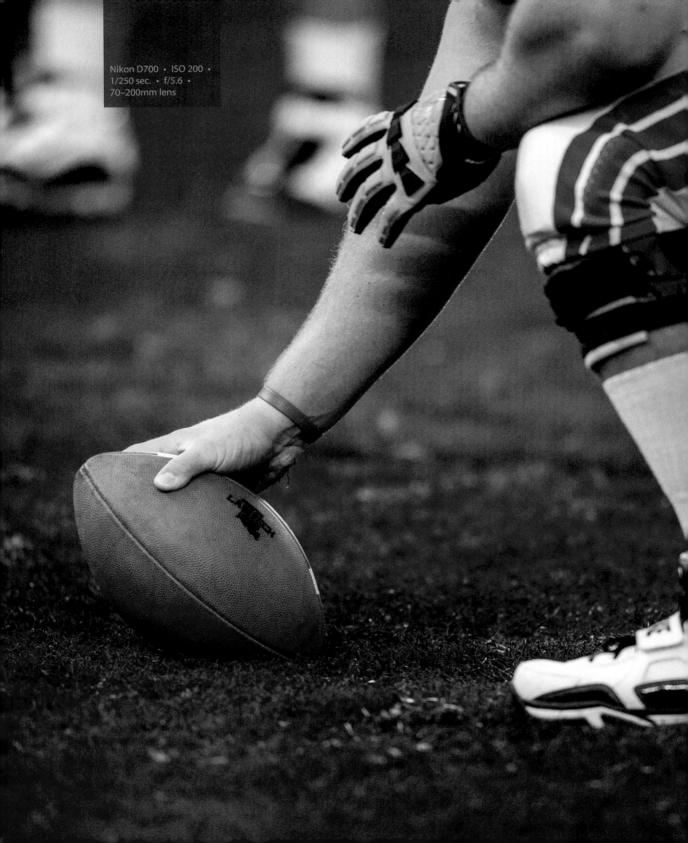

8
Getting the Sharpest Photos Possible

Methods to get tack-sharp images in a variety of situations

By now, you should have a solid understanding of focus modes, points, and areas. You're well on your way to capturing great shots that are in focus and really sharp—but there's one more piece of the equation to consider. Not only do we need to use the right focus mode and focus area, but we also need to use the right gear and techniques. This chapter covers all those extras that enable you to get the best results in variety of situations, from action shots to landscapes.

Poring Over the Picture

I used a tripod and cable release to keep the camera rock-steady during the exposure.

A deep depth of field ensured items in the foreground as well as the background appear in sharp focus.

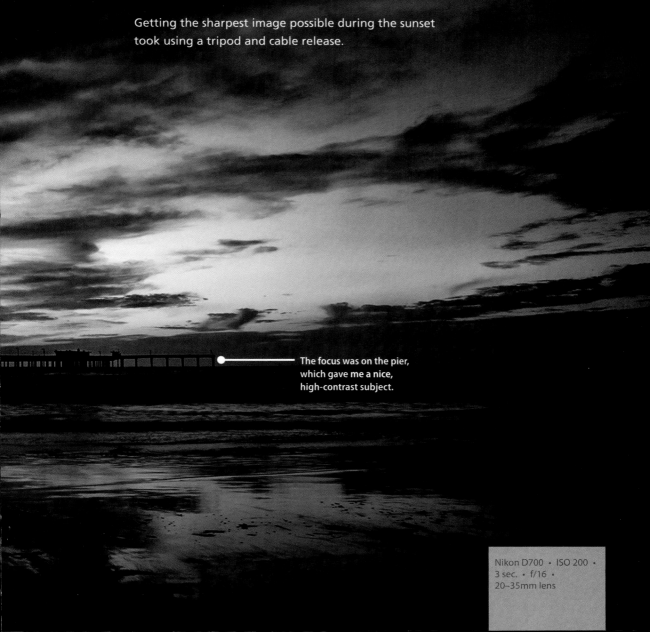

Getting the sharpest image possible during the sunset took using a tripod and cable release.

The focus was on the pier, which gave me a nice, high-contrast subject.

Nikon D700 · ISO 200 · 3 sec. · f/16 · 20–35mm lens

Poring Over the Picture

Because the focus was on the player, the ball was slightly blurred as it traveled toward me.

This action shot was taken during the soccer practice, so knowing where and when the action would take place was much easier.

The shallow depth of field kept the focus right on the player and blurred the background nicely.

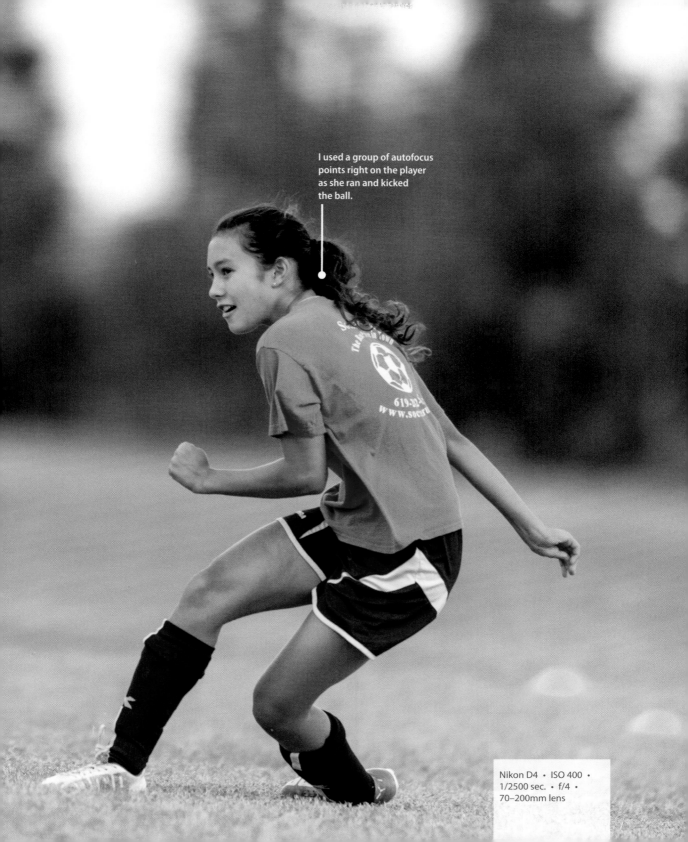

I used a group of autofocus points right on the player as she ran and kicked the ball.

Nikon D4 · ISO 400 ·
1/2500 sec. · f/4 ·
70–200mm lens

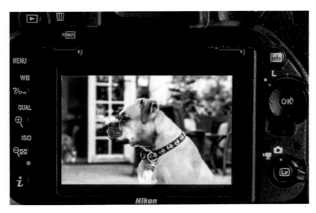

Figure 8.1
The screen on the back of the Nikon D750 shows the whole image, and everything looks like it's in sharp focus.

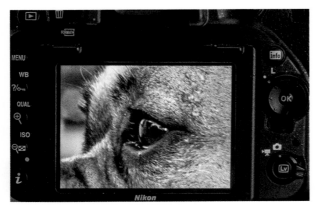

Figure 8.2
Zoom to 100 percent to check the focus more accurately, as demonstrated here on the back of the Nikon D750.

Figure 8.3
With this menu choice on the Nikon D750 you can set the OK button to zoom the display to 100 percent.

Check Focus at 100 Percent

One fantastic advantage of digital cameras is the ability to immediately check your results on the back of the camera. You can instantly find out if the exposure is right or needs adjustment. You can see if you captured the moment or missed it, and you can look at the composition and decide if it's pleasing or it needs work.

You can also look to see if the image is in focus or not. The problem is that the screen can lie to you (it's not your friend), and images that you *think* are in sharp focus end up with a blurry subject. I cannot tell you how many times this has happened me. I take a great shot, glance at the back of the screen, and think everything looks good, like in **Figure 8.1**. Then, I get home and look at the image on the computer. The shot that looked great on the camera is now out of focus—not great. The solution is to make sure that you zoom in to 100 percent when you look at the image on the back of the camera. This way you can better see whether the critical area is in focus (**Figure 8.2**).

Some cameras allow you to use a button on the back of the camera as a 100-percent zoom when previewing the images. I love this feature because it makes checking the focus on the back of the camera so much easier. On the Nikon D750, for example, I set the OK button located in the center of the four-way rocker switch as 1:1 (100%) zoom (**Figure 8.3**).

Photographing Landscapes and Long Exposures

When photographing landscapes or other long-exposure images, you need to use the proper settings and to keep the camera perfectly still during the entire exposure. The first thing to do is set the camera up to give you the best results, which means not only adjusting the focus settings but also using the right aperture and picking the right spot to focus on. Securing the camera to a tripod and using a cable release to control the shutter gives you the best chance to keep the camera still.

Camera Settings

To get those beautiful landscape photos where everything from the foreground to the background is in focus, you need to use a deep depth of field and make sure your focus is in the right spot. Start with an aperture of f/16, which creates the deep depth of field, and then place the focus point at a spot one-third into the scene.

Because the landscape isn't moving and the camera will be locked into a tripod, you can use single-subject autofocus and a single focus point. If there is nothing in the frame for the camera to focus on at one-third into the frame or there isn't enough texture, then you can switch to manual focus. I've rarely had to resort to this, however. In **Figure 8.4**, I focused on the pier about half of the way into the frame, and the whole image looks to be in sharp focus. The same thing works when photographing landscapes in portrait orientation; in **Figure 8.5**, the rocks in the foreground, as well as the clouds and trees in the middle ground and background, are in focus.

If you don't want the whole frame to be in focus, then you should use a shallower depth of field and put the focus point on the area that you need to be in focus. When you're shooting landscapes with a wider-angle lens, however, most of the frame is going to be in focus anyway.

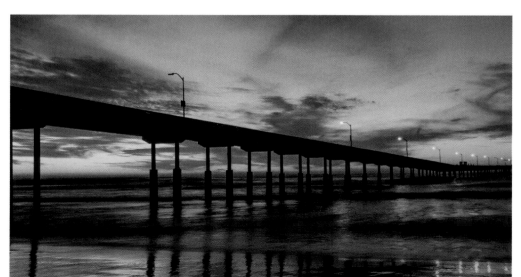

Figure 8.4
To photograph the pier at Ocean Beach at sunset, I set the focus point on the piling about one-third of the way into the frame.

Nikon D700 · ISO 200 · 3 seconds. · f/16 · 20–35mm lens

Figure 8.5
I photographed this small stream in Colorado from an overhanging rock and kept the focus point about one-third of the way back into the frame.

Nikon D1X · ISO 200 ·
1/320 sec. · f/9.0 ·
12–24mm DX f/4.0 lens

Tripods

One of the most common reasons for images to be blurry is that it is difficult to hold a camera steady when taking a photo, especially when using slower shutter speeds or longer focal lengths. The best solution to counteract this is to use a tripod or monopod to keep the camera and lens steady.

A tripod is a three-legged support for your camera and lens. Many of the better tripods are actually two pieces: the tripod legs and the tripod head. You can mix and match the type of tripod head with the tripod legs to get the best combination for your photography. The factors to consider when looking for a tripod are:

- **Weight.** The weight of the tripod will determine if you actually take it with you or if it stays in the studio. The lighter the tripod, the easier it is to pack and carry for use in the real world. You need to find the right balance between weight and other factors, however. It is no good to have a very lightweight tripod if it doesn't provide a solid support for your gear.

- **Height.** The height of the tripod is determined by the length of each of its leg segments as well as its number of leg segments. Many tripods come with a center column that can raise the camera and lens even higher, but by it's very nature, this center column is not as stable when it is raised. You need to make sure that the tripod is the right height for you with the center column lowered. You want the tripod to be tall enough so that you can comfortably stand behind your camera and look through the viewfinder or see the screen on the back clearly.

- **Support Load.** For the tripod to work correctly, it needs to be able to support the weight of your camera and lens, which can range from a few to many pounds. For example, the 14–24mm Nikkor lens weighs 35.3 ounces. When you attach it to the Nikon D810, which weighs another 36 ounces or so, the total weight reaches 72 ounces or 4.5 pounds. The Canon 400mm f/2.8 lens alone weighs in at 135.8 ounces—nearly double the previous lens-camera combination. So, make sure you get a tripod that can handle not only the gear you have, but also the gear you plan on getting.

- **Materials.** Tripod legs are made from a wide variety of materials, including traditional wood, aluminum, and carbon fiber. Each of the materials has its own advantages and disadvantages. Carbon fiber tripods, for example, are more expensive than the aluminum tripods but are lighter. Wood tripods can be very heavy and expensive, but they can also be the most stable.

- **Tripod Head.** The tripod head is the piece on the top of the tripod legs that actually holds and positions the camera and lens. There are two basic types of tripod heads: ball heads and pan-tilt heads (**Figures 8.6** and **8.7**). A *ball head* consists of a ball and socket that you can quickly adjust and lock into place, enabling you to position the

Figure 8.6
The Nikon D2X with the 80–400mm lens locked into a tripod with a pan-tilt head.

Figure 8.7
The camera is mounted to a ball-head tripod, which allows you to move the camera and then lock it into position with a single knob.

camera with one control. Ball heads are usually more expensive than the same size pan-tilt head. *Pan-tilt heads* have three controls, one for each axis. These heads allow you to fine-tune the camera placement easily and precisely, because you can keep two of the axes locked while adjusting only the third.

For the sharpest landscape photos, you need to use a tripod to hold the camera rock-steady during the exposure. A tripod is not an option but a necessity.

Cable Release or Remote

Even when you firmly mount your camera on a tripod, one more thing can still blur your long-exposure images: the small vibrations from pressing the shutter release button.

To get the sharpest possible photos of landscapes or any long exposure, you need to trigger the shutter release button remotely with a cable release or wireless remote. A *cable release* (**Figure 8.8**) allows you to trigger the shutter release without actually touching the camera. Cable releases also free you from the restriction of the 30-second limit most cameras have on the shutter release time by enabling you to use blub mode. In bulb mode, the shutter will stay open as long as the button on the cable release is held down or locked open.

Figure 8.8
A cable release attaches to the camera, allowing you to trigger the shutter without actually touching the camera.

Figure 8.9
The Nikon ML-L3 remote can trigger the D3200 without your needing to touch the camera. Simply set the camera to one of the remote triggering modes in the Drive menu.

A *wireless remote*, like the one in **Figure 8.9**, also allows you to trigger the camera without touching it. Many cameras have the capability to use a remote trigger, but you usually have to enable specific settings to do so. Check your camera manual for the remote capabilities of your camera.

If neither of these is available, you can always use the built-in self-timer, which allows the camera to settle after you press the shutter release button. When the timer goes off, the camera takes the image.

Shooting Sports and Action

Capturing a great sports shot takes skill, timing, the right settings, and sometimes a little luck. I can't help with the luck part, but using the right settings and the right gear can improve your chances of getting a great shot.

To freeze the action, you need to use a fast-enough shutter speed, usually 1/500 second or faster, depending on the action. To get that shutter speed, you need a lot of light or you need to use a wide aperture and a higher ISO.

Focus Mode and Area

The first part, the focus mode, is easy. When shooting sports and action, you need to use continuous autofocus mode so that the camera keeps trying to maintain focus for the subject. The second part, the AF area, is more difficult as it depends on the sport, your preference, and your shooting style. For some sports, I use a single focus point or a small

group of AF points as it gives me the most accurate focus between all the players. For sports like surfing where there is a single subject, I will use more focus points to help track the subject (**Figure 8.10**).

If I know where the action is going to take place, I use a single AF point and pre-focus so that I increase the odds of getting the shot. For example, when photographing a hockey game, I put the focus point right on the goal upright when the team is close to the net. In **Figure 8.11**, you can see that the action is in focus, and you can even see the puck in the back of the net. Had I tried to get that shot by following the puck, it never would have happened. Instead, by focusing on the goal itself, I was able to capture the team scoring.

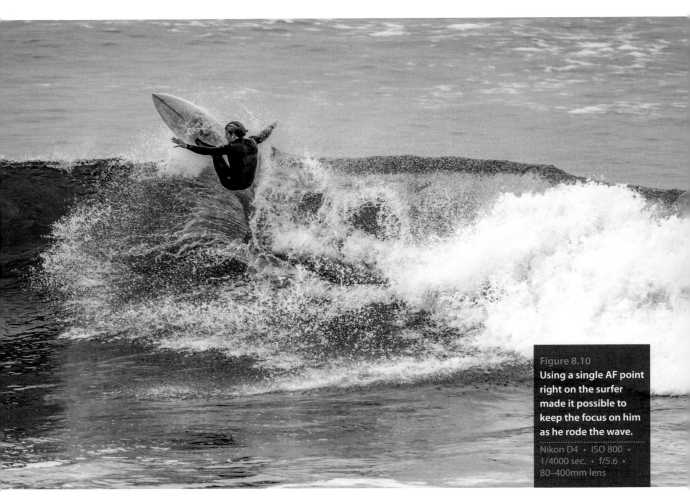

Figure 8.10
Using a single AF point right on the surfer made it possible to keep the focus on him as he rode the wave.

Nikon D4 · ISO 800 · 1/4000 sec. · f/5.6 · 80–400mm lens

Monopods

A monopod is basically a stick used to help you support your cam-
era and lens. Although a monopod isn't as stable as a tripod, it can
make a world of difference, especially when using longer focal
lengths. Watch any professional sporting event, and you will see
that the photographers on the sidelines use monopods to help
support the weight of those big, heavy lenses. Using a monopod
enables you to retain the freedom to move quickly to follow the
action while being supported to help avoid camera shake. Those
long lenses can get very heavy after only a few minutes when you
try to support them with just your arms!

The monopod usually attaches right to the tripod-mounting
bracket on the lens rather than the camera (**Figure 8.12**). This helps
support the heaviest part of the camera-lens combination. I use a
monopod to shoot sports all the time as it allows me to support
the longer, heavier lenses and still gives me the ability to follow
the action. When shooting anything with a lens over 300mm, you
will want to use a monopod.

Figure 8.12
A monopod adds stability when you're using
longer focal lengths. The monopod usually
attaches right to the lens.

Limit the Focus Distance

The long lenses used by sports photographers have switches that limit the distances at which the lens will focus. By limiting the distances, the lens doesn't have to search the whole distance from the minimum focusing distance to infinity but instead can just concentrate on the area where the action is happening. This might not make the image sharper, but it will help you get the focus locked quicker. For example, when shooting a college football bowl game years ago, I set the limiting switch on the 400mm f/2.8 lens to just look at infinity to 6 meters, or roughly infinity to 20 feet. This meant that the lens focused faster on the runner in **Figure 8.13**; he was more than 20 feet away, and the lens didn't need to hunt through the full range of focusing distances.

Figure 8.13
With the ball tucked into his arm, the football player made a run for the first down. The focus locked onto the runner quickly because the distance switch on the lens limited the focusing distance.
Nikon D3 · ISO 3200 · 1/1600 sec. · f/2.8 · 400mm lens

Low Light

Getting a sharp, in-focus image in low light can be a challenge because the camera needs light to focus. This can be an issue when shooting events or any subject in low light. The difference is that for events you don't have the option to use the AF assist or any extra lights, so you have to use timing, wide apertures, and the most sensitive AF sensors in the camera.

AF Mode and Area

I photograph a lot of concerts, and I use the continuous autofocus and a single AF point for most of the shows. When you use a single AF point, make sure it is right over the most important part of the image. This is due to the very shallow depth of field that happens when shooting at the widest possible apertures in low light.

For example, when I photographed my friend Mark playing guitar at a local club (**Figure 8.14**), the lighting was really low, so I used the 35mm f/2 lens opened all the way up to f/2. With the lens wide open and an ISO of 3200, I could use a shutter speed of 1/100 to freeze the guitar action. I made sure that the focus point was on his right hand on the guitar.

Figure 8.14

Photographing musician Mark Karan in concert took some timing, luck, and a wide-open aperture.

Nikon D700 • ISO 3200 • 1/100 sec. • f/2.0 • 35mm lens

More recently I have started to use the Group setting for the AF area. This gives the camera more information to work with as each of the AF points in the group is treated equally, and combined they just act as a single big AF point. The real key is to be able to change between the different AF area modes while shooting without wasting a lot of time. When you're shooting performances, there is usually a very strict and short amount of time allowed.

In **Figure 8.15**, I used Group mode as it just worked better on the hands on the guitar. The bigger AF area gave the camera more information to work with.

Use AF Assist

When you are shooting in low light and it isn't a performance, then it is possible to use the autofocus-assist lamp. Be warned, however, the bright, flashlight-type light can be a huge distraction to the subject. As an alternative, you can try the autofocus assist built into the camera's flash system. I am not talking about the little pop-up flash, but the higher-end dedicated flashes, such as Nikon Speedlights that you can buy for your camera. Some of these flashes use an active autofocus-assist lamp that emits a red light that measures the distance from the camera to the subject and helps the autofocus to work.

Figure 8.15
The group focus area on the Nikon D750 uses the five focus points (the four shown in red and the point in the middle of the group) to focus with.

Nikon D750 · ISO 1600 · 1/250 sec. · f/2.8 · 70–200mm lens

In **Figure 8.16**, you can see the autofocus-assist lamp on the Nikon SB-910, which emits a red light that the subject doesn't even see, but that allows the camera to focus. (For more details on flash assist and Speedlights in general, see my book *Mastering Nikon Speedlights*.)

Use the Cross-Type Sensors

The cross-type AF sensors are more accurate than linear AF sensors. It might not be a huge difference, but if you are looking for the smallest edge, especially when shooting in low light, you want to use the camera's cross-type sensors. If you don't know which ones on your camera are the cross type, chances are they are in the center of the frame.

Slower Shutter Speed Tips

There are times when you want to use slower shutter speeds, either to show the motion in the subject or just because there is very little light. For instance, I saw the skateboarder in **Figure 8.17** riding down the middle of the street, and instead of freezing the action, I used panning to blur the background and show some

Figure 8.16
The Nikon SB-910 Speedlight has a built-in autofocus-assist lamp that can work wonders in low light.

motion in the frame. When *panning*, you use a slower shutter speed and then move the camera at the same speed as the subject so that the subject stays in the same spot in the frame and the background is blurred. For Figure 8.17, I used a 1/10 second shutter speed and matched the camera movement to the skater who wasn't going very fast. It takes a lot of practice to get this technique down, but once you master it, it is very effective. I use continuous autofocus and start with a single focus point right on the subject, then press the shutter release button all the way down and continue to move the camera in the same direction and at the same speed as the subject.

The second reason to use a long shutter speed is when shooting in low light and you need to leave the shutter open to get a proper exposure, but you don't want any blur in the image. In **Figure 8.18**, I handheld the camera for this photo at a concert with a shutter speed of 1/5 of second so that the lights in the background would be captured as well.

To get a steady shot when holding the camera, you need to practice your camera-holding techniques.

Figure 8.17
I kept the focus on the Santa in flip-flops as he skated past. Moving the camera at the same speed as the skater kept him in focus while blurring the background

Nikon D750 •
ISO 1600 •
1/10 sec. • f/18 •
70–200mm lens

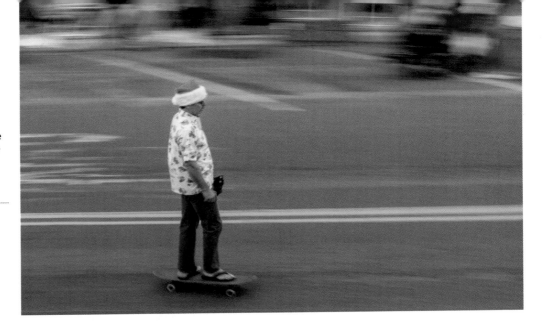

Figure 8.18
To record the lights in the background, I needed a longer shutter speed, so I had to hold the camera steady for 1/15 second.

Nikon D700 • ISO 200 •
1/15 sec. • f/2.8 •
24–70mm lens

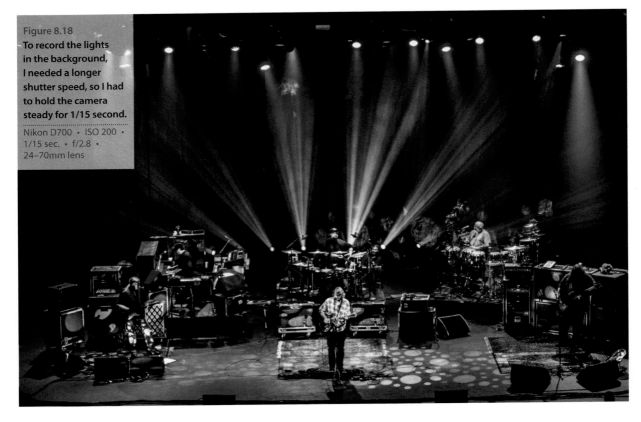

Camera-Holding Techniques

Holding your camera steady while making photographs is important to getting sharp images without a tripod or monopod. Support the camera from under the lens and camera body, but avoid putting your hand on the top, which just pushes the whole thing down. Next, tuck your elbows into your sides so that they are supported and the camera is steady in your hands (**Figure 8.19**). With practice, you can hold your camera extremely steady for very slow shutter speeds. One of the best tutorials on how to hold your camera was done by world-famous photographer Joe McNally, and you can see it on YouTube here at www.youtube.com/watch?v=EDsx3-FWfwk.

Figure 8.19
Holding a camera steady is easier when you tuck your elbows into your sides to support the camera from below.

Vibration Reduction and Image Stabilization

Although its known by several names, a technology that allows you to use slower shutter speeds and still get sharp images is built into many lenses for the Nikon (Vibration Reduction) and Canon (Image Stabilization) systems and into the bodies of the Sony (Steady-Shot) cameras.

This technology does not work with moving subjects. It will *not* freeze fast-moving action, so you need to make sure the shutter speed is high enough to do that. What this technology does is counteract the camera shake that occurs when you try to hold the camera steady during a long exposure. For example, the photos of the light bulb in **Figures 8.20** and **8.21** were shot with Vibration Reduction turned off and turned on, respectively. You can see that the shot with the Vibration Reduction turned on is the sharper of the two. Both were shot with the same camera, lens, and settings, one immediately after the other.

Figure 8.20
The focus point is right on the light bulb filament, but with Vibration Reduction turned off the bulb is slightly out of focus.

Nikon D750 • ISO 100 • 1/30 sec. • f/7.1 • 70–200mm lens

Figure 8.21
With Vibration Reduction turned on, the bulb is much sharper, and you can even see the fine cobwebs clearly.

Nikon D750 • ISO 100 • 1/30 sec. • f/7.1 • 70–200mm lens

Macro Photography

Macro photography allows you to see the world in a different way. By focusing extremely closely on everyday objects, you get to see them in a whole new light. To ensure you see them in the best light, try these tips to make your macro photography easier and increase the odds of getting better photos.

The basics are simple: You need a lens that allows you to get in super close, a tripod to hold the camera rock-steady, and the right settings. Macro lenses have a very short minimum focusing distance, allowing you to get really close to your subject. Use a steady tripod, because even the slightest movement when shooting macro can cause the image to be blurred.

Focus in macro photography is critical because the distance between the camera and subject is so minimal that the depth of field is greatly reduced. There is no wiggle room with the focus as is possible with landscapes or action photography. If the focus is off by even a hair, the whole subject of the image can change.

At times I use the autofocus for macro photography, especially if the subject has a lot of texture and contrast so the camera has enough information to work with. For example, the fern in **Figure 8.22** has enough detail for the autofocus to lock onto. All those tiny hairs give the camera something to use to focus on. The basic setup is then to use the single-servo autofocus with a single AF point right over the critical spot in the image.

Figure 8.22
An extreme close-up of the hairs on a fern makes for an interesting view and is something that you wouldn't normally see.
Nikon D2H · ISO 200 · 1/90 sec. · f/4.8 · 105mm lens

Figure 8.23
Here, you can see the Nikon D750 in a tripod set up to photograph the inside of the Bird of Paradise flower.

The more common setting when shooting macro images is to use manual focus. **Figure 8.23** illustrates the basic setup for shooting a macro image of the flower. Now, I didn't want to kill the flower, so I photographed it outside on day with no breeze at all so that the flower didn't move. With the camera on a tripod and placed close to the subject, I used the viewfinder to compose the image. With the camera on manual focus, I adjusted the focus using the focus ring on the lens.

I shot **Figure 8.24** using manual focus. The final focusing was done in Live View mode, where I could zoom into the critical spot of the frame and make sure that the focus was right where it needed to be. (For more on zooming in to focus, check out the section on video focusing in Chapter 9.)

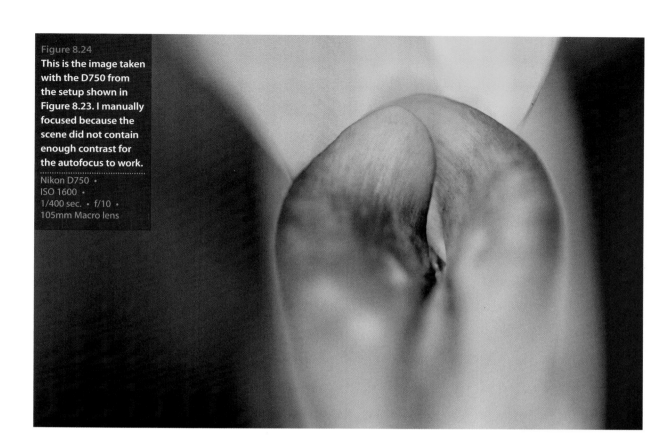

Portraits

When it comes to taking portraits, the most important rule is to make sure that the eyes are in focus. A great photo can be ruined if the eyes are out of focus. The simple answer is to use the single-servo focus mode and a single AF point right over the subject's eye, as you can see in **Figure 8.25** where the focus point is shown in red.

At times you will want to take a photo of someone, but the focus points in your camera will not line up over the eye of the subject. In these cases, you will need to focus and recompose the image using the same autofocus settings: single-servo mode with a single AF point. Place the AF point over the eye of the subject and press the shutter release button halfway down until the focus is locked, then before actually taking the photo, change the composition without changing the distance between the camera and the subject. In **Figure 8.26**, you can see that the focus points are nowhere near the subject's face. I first focused on Nicole's face, then lowered the camera to get the composition I wanted before pushing the shutter release all the way down.

Figure 8.25
The focus point is directly on the eye of the cowboy, making sure it is in sharp focus.

Nikon D750 • ISO 800 • 1/250 sec. • f/8 • 24–70mm lens

Figure 8.26
As you can see from the overlay, the focus points were nowhere near Nicole's eye, but by recomposing the shot after focusing, I caught the eye in sharp focus.

Nikon D750 •
ISO 1200 •
1/100 sec. • f/5.0 •
24–70mm lens

Having the focus right on the eye is also important when photographing animals. Most pets are well behaved and will sit still—until they don't and jump up or move at the worst possible time. So instead of using the single-servo autofocus mode, I use the continuous autofocus mode, which keeps focusing until you press the shutter release all the way down. When you use the continuous autofocus, you cannot recompose the image because the camera will keep refocusing as you move it. To recompose when using continuous autofocus, you need to use the back-button focus so that the focus is not activated when you press the shutter release button halfway down, but instead is tied to another button on the camera. (Setting this up is covered back in Chapter 1.) This technique allows you to focus on the eyes of the subject, then stop focusing and change the composition. If the subject starts to move, you can quickly activate the focus. This is the technique that I used in **Figure 8.27** to get the focus directly on the eye of the cat. The focus point was really close, so all it took was a very slight movement of the camera after the focus was locked to get the eye in sharp focus.

Figure 8.27

The focus is right on the eye of the cat, which is slightly above all of the focus points.

Nikon D4 • ISO 800 • 1/400 sec. • f/2.8 • 70–200mm lens

Chapter 8 Assignments

Try Shooting in Low Light

Practice using a tripod and cable release to shoot in low light. Try different focus settings to see how each one works and the best spot to focus on. The key is to make sure that the camera is held rock-steady in the tripod during the exposure, so make sure the tripod is on secure ground.

Try the Vibration Reduction / Image Stabilization

If you have a lens with the Vibration Reduction or Image Stabilization technology, go ahead and try it using very low shutter speeds. Pick a subject that isn't moving, and try to get a sharp image with and without the the Vibration Reduction or Image Stabilization. Keep using slower and slower shutter speeds just to see how well it works for you. If you have a camera with the stabilization technology built into the camera, go ahead and try it with your favorite lens.

Take a Macro Photo with Manual Focus

The best thing about macro photography is that there are wonderful subjects everywhere you look. Just go outside and photograph a leaf or a flower, but use manual focus to do it.

Focus on the Eyes

Grab a friend or a pet or a friend's pet and practice focusing on the eyes. Start with the focus point right on the eye and then work on focusing and recomposing. This way you will be ready to do either when it counts.

Share you results with the book's Flickr group!
Join the group here: flickr.com/groups/focusandautofocus_fromsnapshotstogreatshots

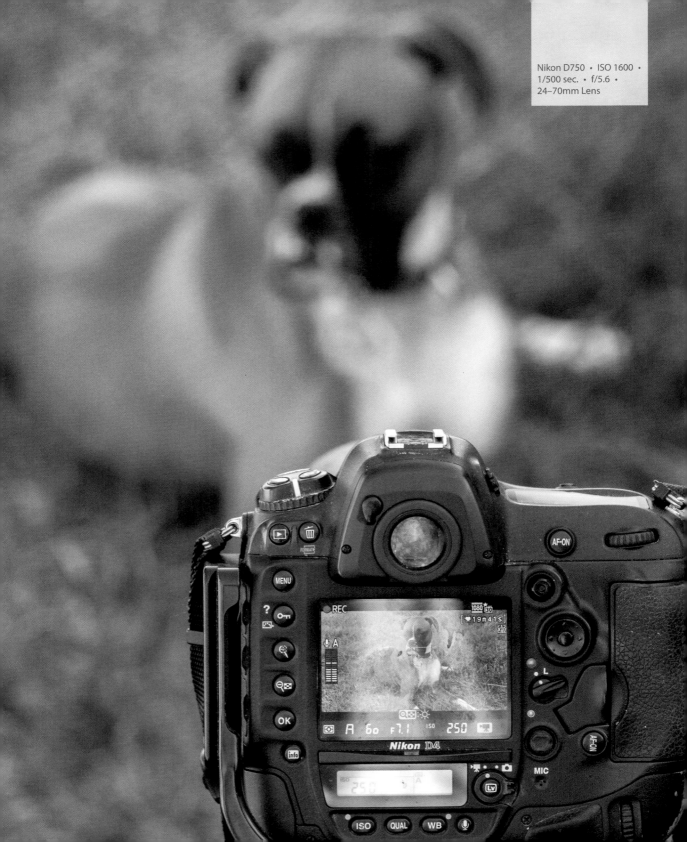

Nikon D750 · ISO 1600 ·
1/500 sec. · f/5.6 ·
24–70mm Lens

9
Focus on Video

Manual focus and autofocus when shooting video with your DSLR

Your camera is no longer just a device to capture still images; it is also a very capable video camera. The video revolution started back in 2008, when Nikon and Canon released the first DSLR cameras that could record video clips. Since then, camera manufacturers have advanced the video-recording capabilities of DSLRs to the point where they are used to create movies and television shows. Cameras such as the Sony A7 RII can record full 4K video for a fraction of the price you would have had to pay a few years ago.

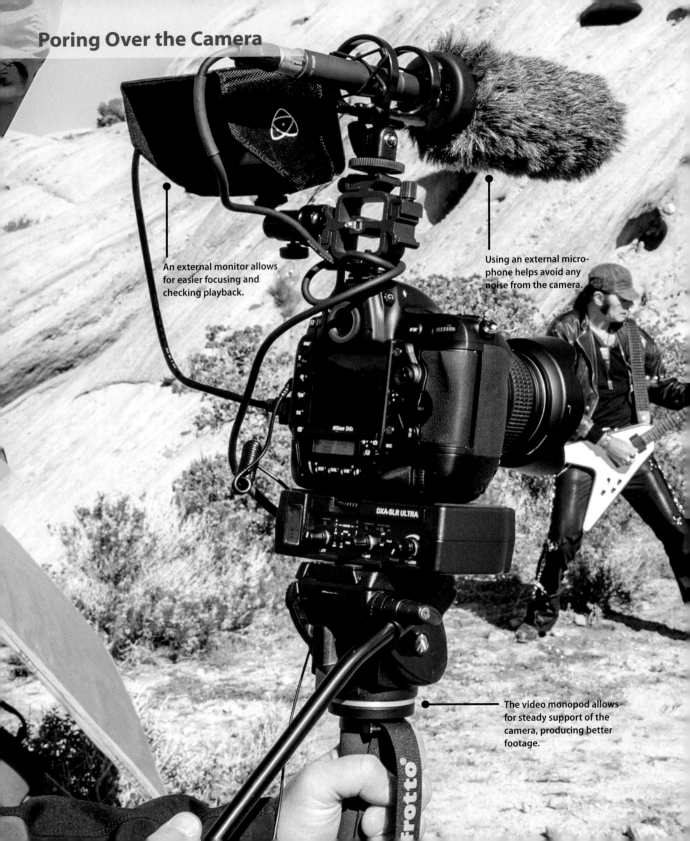

Poring Over the Camera

An external monitor allows for easier focusing and checking playback.

Using an external microphone helps avoid any noise from the camera.

The video monopod allows for steady support of the camera, producing better footage.

On location at the Devil's Punchbowl, filming the behind-the-scenes for the Accept "Stampede" music video using a Nikon D4S DSLR.

Nikon D4 • ISO 400 • 1/640 sec. • f/8.0 • 24–70mm f/2.8 lens

The screen on the back of the Nikon D4 during video recording. There is a lot of information, but the key autofocus elements are the AF mode, autofocus area, and focus point.

AF-S [WIDE]

The autofocus area mode is set to wide for this shoot, giving the camera a larger area to focus on.

SD* 1080★ 30

[🎥20m00s]

XQD

The autofocus mode for the video is set for a single subject.

The focus area turns green when the subject is in focus.

🔲➕✛:🎙✛☀

F7.1 ISO 320

Nikon D4

DSLR Video History

Nikon was the first to announce a DSLR with video capture: the Nikon D90. Canon followed very quickly with the Canon 5D Mark II, which really changed the game. Neither camera was designed for the general population, but nor were they designed for Hollywood studios. Instead, they were meant for photojournalists out on assignment. The thought was that these photographers could capture a few video snippets to go along with the still images to run on the news websites that were gaining a lot more traction. The age of the multimedia photographer was upon us.

Although Canon and Nikon greatly increased the functionality of their cameras by adding video capture, DSLR cameras were not initially designed to shoot video. A few challenges remained for photographers, and chief among them was focusing while shooting video. The first video-capable DSLRs produced surprisingly good video for the price and size of the camera, which made these cameras desirable in Hollywood where the focusing limitations were nothing compared to the savings in price.

One of the biggest drawbacks of the early video capability was the lack of autofocus. For example, the Nikon D90 allowed you to focus by pressing the shutter release button halfway down before starting to record video. Once the video started to record, however, there was no autofocus. This wasn't an issue for the Hollywood filmmakers who used manual focus all the time, but it was an issue for amateur photographers who just wanted to record a little video. The Canon 5D Mark II allowed you to activate the focus during video recording, but it wouldn't automatically keep focusing during the movie creation.

Things have come a long way since these first-generation cameras, and now even our smartphones can record HD video. I was actually quite late to the DSLR video bandwagon. The Nikon D4 was the first camera that I owned that actually captured video. I also have used the D3200, a beginner, consumer camera that captured full HD video. Now, I turn to the Nikon D750 (**Figure 9.1**) for most of my video needs. The tilting rear screen makes it easier to compose video because I can see the screen at a variety of angles.

Figure 9.1
Being able to tilt the Nikon D750's screen allows me to use it at a variety of angles and still see what the camera is recording.

Manual Focus

When I first started trying to shoot video with my DSLR, the autofocus didn't work very well, but the bigger issue was that the camera would pick up the sound of the lens motor as the camera tried to keep the subject in focus. The placement of the microphone on the camera body (shown in **Figures 9.2** and **9.3**) made it perfect for recording the sounds from the camera rather than the subject. The autofocus also would hunt as it tried to keep the subject in focus, so the scene would go in and out of focus as the subject moved. If the subject moved erratically, focus was even more difficult.

Figure 9.2
The microphone (those three little dots) on the Nikon D3200 is located too close to the lens and picks up any noise from the camera focusing.

The answer is to use manual focus in the same way as the Hollywood studios. One of the main techniques that Hollywood cinematographers use is *pulling focus* or *rack focus*. With this technique, the focus starts on one object in the scene then gradually changes so that a different subject, one that is closer or farther away, is in focus. You can practice this technique yourself with two stationary subjects, one in the foreground and one in the background. Start with the focus on the object in the foreground, then slowly and smoothly turn the focusing ring on the lens until the object in the background is in sharp focus. **Figure 9.4** shows the setup for this; the camera is in a tripod, and the two toys are at different distances from the camera. You can see the video from this shoot online after you register your copy of this book at peachpit.com. I focused on the first toy, used a small piece of tape to mark the position where that was in focus, and then did the same for the second toy. This allowed me to go from one to the other without having to wonder if I was in focus or not.

Figure 9.3
The microphone on the Canon 5D Mark III is located at roughly the same spot, on the front, close to the lens.

Another manual focusing technique that you can use is to *throw focus*, which is to start with the subject in focus and then slowly go completely out of focus, or start out of focus and slowly turn the focusing ring until the subject is sharp.

All this sounds rather easy but can be difficult to master, especially because you cannot use the optical viewfinder on DLSR cameras. The mirror is moved up out of the way so that the sensor can record video. Instead, you have to use the screen on the back of the camera, which can be problematic in bright light.

Figure 9.4
Here, the Nikon
D750 is set up to
shoot video using
pulling focus.

You can buy some great accessories to help with video focusing, however. The first, and maybe the most important, is a *video loupe* that mounts on the back of the camera over the screen. You can bring your eye to the loupe, and just like a proper viewfinder it blocks out the ambient light. You can also buy an external monitor that gives you a larger view of what is being recorded. There are also focusing systems that allow you to manually adjust the focus of the lens more smoothly.

Video AF Modes

Each camera manufacturer has a different method of autofocus for Live View mode and video recording. The one thing that they all have in common is the manual focus mode, where you just turn the focusing ring on the lens.

The two common autofocus modes are single-servo mode and continuous autofocus mode. In the first mode, you lock the auto-focus before shooting video and then record the clip without the subject or camera moving. In the second, the camera tries to track the subject and maintain autofocus.

In the single-servo mode, you press the shutter release button down halfway to activate the autofocus. Once the subject is in focus, you can then start recording the video, but if the camera or the subject moves, the subject will go out of focus. The Canon cameras actually flip the mirror down and use phase-detection autofocus to achieve focus, then flip the mirror back up and out of the way. Single-servo mode (**Figure 9.5**) works well for film-ing stationary subjects, like those you would see during an inter-view. Because the camera and the subject don't move during the filming, the autofocus doesn't have to try to focus during the clip. Because neither the camera nor lens focusing motor has to engage, the camera has no chance to pick up unwanted noise from focusing motor's noise.

Continuous autofocus mode tries to keep the subject in focus throughout the video recording (**Figure 9.6**). This mode is what everyone expects from video recording: The subject stays in focus no matter how it moves or where it moves in the frame. Although the mode does a pretty good job, especially compared to the capa-bilities of older generations of cameras, it is still not perfect.

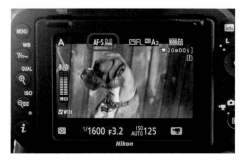

Figure 9.5
The screen on the back of the Nikon D750 shows that it is set for video recording, with the autofo-cus set to single-servo mode.

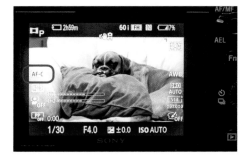

Figure 9.6
This Sony A 7II is set to record video using AF-C, or continuous autofocus mode.

The camera uses the contrast-detection method of autofocusing, which means the camera isn't sure that the focus is locked until it actually goes past the focus point and back. You can see the camera doing this as you focus on something while filming. The video will seem to focus on the subject, then quickly refocus.

The newer Sony cameras allow you to adjust how fast the camera actually tries to autofocus when shooting movies. You are able to adjust the Movie AF drive speed between Fast, Normal, or Slow. Remember to check your camera manual to see if your camera can do this.

Video AF Area Modes

When you are shooting video, you can choose among numerous area modes that try to make it easier for the camera to lock onto moving (and stationary) subjects. The basic modes deal with how much of the frame to use for focusing from a small area to a larger area. Some cameras have extra modes with face tracking and other methods of tracking the subject. All these modes make it easier for you to focus and keep focus on the subject, but remember that all of these can still cause the camera to hunt for focus, which does ruin the shot.

The basic modes are normal mode, wide mode, and tracking mode. *Normal mode* has a smaller focus area and works well for subjects for which you need a very accurate focus and that probably won't move. This mode is also best when there is a lot of contrast in the area under the focus point. On the Nikon D750 in **Figure 9.7**, you can see the regular focus point over the arrowhead.

Figure 9.7
The normal mode focus point isn't very big; you can see it over the arrowhead. Because the focus point is green, the area under it is in focus.

The second AF area that you can use is a bigger version of the same focus point. *Wide mode* uses more of the frame's area to focus and is a good choice for subjects that have less contrast and when the camera needs more information. It is also better for moving subjects because it can help with the tracking as they move. In **Figure 9.8**, you can see the wide area AF zone on the Canon 5D Mark III.

Figure 9.8
Here, you can see the wide area AF on the Canon 5D Mark III.

The final AF area mode is the one with the most promise, but it is also the most frustrating to use. Although it can track a moving subject, *tracking mode* doesn't always track in the way you think it will and fast-moving subjects can get ahead of the focusing. I have used this mode and got some good footage, and I have used this mode and got some unusable, out-of-focus footage. Before relying on this mode in a production setting, experiment with how it works for you on your camera. In **Figure 9.9**, you can see tracking mode set up on the Nikon D750.

Figure 9.9
This Nikon D750 is set up to shoot video with the AF area face-tracking mode turned on.

Tips for Better Video

No matter which mode you use, you can take steps to create better video from your DSLR. The following tips might not all help you focus, but they will improve the overall look and sound of your videos.

Use a Tripod or Monopod

The best tip for improving your video is to get a video tripod, or at least a video monopod, so that the camera is stable when shooting. Unlike still-photography tripods and monopods, video tripods and monopods have fluid heads that enable you to smoothly move the attached camera. You can control how easily the camera can pan and move, but the key is that the movement is extremely smooth so that the movement in the video is equally smooth. I have a video monopod (**Figure 9.10**) that has a fluid head so I can tilt the camera up and down smoothly.

Fast movements with the camera might be fine for taking still shots because you don't see the motion between shots, but with video, slow and steady is more professional. Using a tripod or monopod will help you slow down.

Figure 9.10
Using a video monopod allows Scott to keep the camera steady and adjust the focus, sound, and other settings.

Figure 9.11
This Rode video microphone is mounted in the camera's hot shoe and then plugged into the microphone jack on the side of the camera.

Figure 9.12
The video loupe goes over the back of the camera, allowing the LCD screen to act as a proper viewfinder, thus allowing for better focusing.

Don't Ignore the Sound

I know it has nothing to do with the focus, but one of the aspects that separates good video from great video is the sound. The newer DSLR cameras come with not only a built-in microphone or two, but also a microphone jack that enables you to use an external microphone. There are numerous microphones available for recording video—from lavaliere microphones, which the subject can wear, to shotgun microphones, which attach to the camera's hot shoe (**Figure 9.11**). If you are going to take making videos seriously, look into the various types of microphones available to you.

Many videographers use a separate audio recording device that allows multiple audio sources to be recorded, and then they sync the separate audio with the video in postproduction. It all depends on how far you want to take video recording.

Get a Video Loupe

A video loupe (**Figure 9.12**) attaches to the screen on the back of the camera, blocking out the ambient light. It allows you to better use the screen as a viewfinder so that you can zoom in and focus, watch the recording, and check playback easily.

Plan Ahead

Hollywood movies are scripted and very carefully planned out. This makes it easier to get the footage that you need and can help you make the movies you want. It's a lot easier to focus on the subject when you know where the subject will start out and where it is going.

If possible, try to get more than one video take, just as you would take more than one photo.

Use an External Monitor

For precise focusing, using an external monitor can make a difference. Not only is an external monitor bigger and brighter with higher resolution, but, most importantly, it can be positioned where the camera operator needs it the most, off to the side or above the camera. The external monitor attached to the camera in **Figure 9.13** is positioned above the camera for easier and more accurate focusing. An external monitor also helps when playing back the video to see if you got the footage you needed.

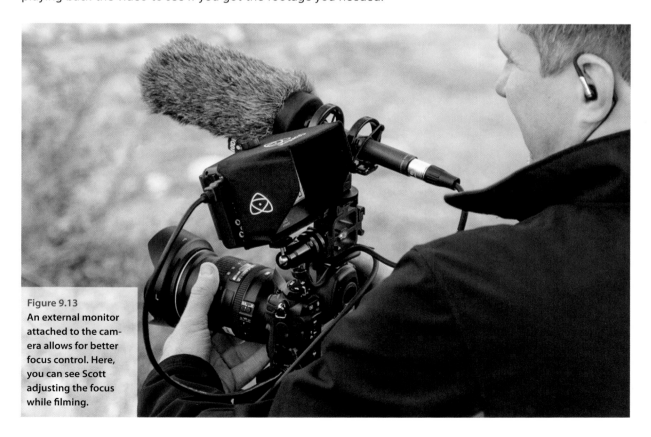

Figure 9.13
An external monitor attached to the camera allows for better focus control. Here, you can see Scott adjusting the focus while filming.

Use a Deeper Depth of Field

Using a deeper depth of field means that more of the scene in front of the camera is in acceptable focus. So shooting the same scene at f/16 gives you a lot more area in focus than when you shoot it at f/2.8. This might not be the most creative way to record a scene, but it is a good way to start.

Practice Manual Focus

Manually focusing is not that easy, so if you want to get good at it, you need to practice. Start by practicing on subjects moving across the frame and parallel to the camera. If the distance from the camera doesn't change much, then the focus won't need to change much. Once you have that mastered, then it is time to start with the subjects moving toward and away from you. That is a lot harder, as you need to adjust the focus at the same rate as the subject is moving, so start with a slow subject and work your way up to faster-moving subjects.

Zoom in for Better Focus

One of the great things about shooting video on a DSLR is that you can zoom into the scene and check the focus at a much more critical detail level. This allows you to really get in close to check the focus on the critical part of the image and works fantastically well, as long as the camera and subject don't move too much. In **Figures 9.14** and **9.15**, you can see that zooming in allows you to more precisely see the spot to focus on. Now, when I talk about zooming in, I am not zooming the lens in or changing the focal length, but instead I am looking at what the sensor is recording at higher magnification. On the Nikon D750 that is accomplished by pressing the playback zoom button (the one that looks like a magnifying glass).

Figure 9.14
Using the normal view on the back of the camera, it is not that easy to see the focus and detail.

Figure 9.15
It is much easier to zoom in and see exactly where the focus is.

Chapter 9 Assignments

Test Your Camera Shooting Moving Subjects

It's fun to just turn on the camera, set the autofocus and just shoot some video. Set the camera to continuous autofocus, press the shutter release button halfway down to activate the autofocus, and start to film once the focus is locked. Then, watch how the autofocus hunts when the subject moves. Knowing how the camera acts will help you when planning out a video shoot.

Study the Different AF Modes for Video

Figure out which video autofocus modes your specific camera has and practice switching between them. Check your camera manual for the different modes and how to switch them. Chances are it's the same way as you switch the modes when taking regular photos.

Practice Using Manual Focus

Getting the best results with manual focus in video takes practice—lots of practice. Place the camera in a tripod or on a stable surface and practice focusing on a static subject. Once you can do that, it's time to practice switching focus from one subject to another at different distances from the camera.

Share you results with the book's Flickr group!
Join the group here: flickr.com/groups/focusandautofocus_fromsnapshotstogreatshots

Index

D

Day of the Dead celebration, 106

depth of field, 38, 41

 DSLR video, 172

 explained, 36

diopter adjustment, 122–123, 129

distance-limiting switch, 53

DMF (Direct Manual Focus), 35. *See also* manual focus

dog photos, 13, 53, 60, 77–78, 93, 111, 125

DSLR video

 AF modes, 167–169, 173

 audio, 170

 depth of field, 172

 external monitor, 171

 history, 164

 loupe, 170

 manual focus, 165–167, 172–173

 monopods, 169

 moving subjects, 173

 Normal mode, 168

 planning ahead, 171

 tracking mode, 169

 tripods, 169

 Wide mode, 168

 zooming for focus, 172

Dynamic Area AF, 11, 30–31, 88–90

E

exposure

 and AF points, 74

 and focus, 36–40

external monitor, using for video, 171

eyes, focusing on, 153–157

F

Face Priority AF, 32

face-tracking mode, 169

fast-moving subjects, shooting, 95, 110

fences, shooting through, 108–109

fireworks, photographing, 5–6, 127–128

flat subjects, photographing, 90

Flexible Spot focus area, 35

FlexiZone modes, 34

focus. *See also* autofocus

 and aperture, 36–38

 checking at 100 percent, 136

 and shutter speed, 39

 testing, 15–16, 19, 112

focus areas

 looking for, 115

 Nikon D750, 50

 Sony A7 RII, 49

 for sports and action, 141–143

focus controls. *See also* lens controls

 AF area selector, 49–50

 AF mode selector, 48–49

 AF/MF switch, 48

 on camera, 7

 on lens, 8–9

focus modes. *See also* AF modes; manual focus; pre-focus

 choosing for subjects, 4

 Nikon D750, 50

 for sports and action, 141–143

focus plane, 36

focus points. *See also* AF points

 and aperture, 75–76

 Canon EOS 5D Mark III, 70

 Canon EOS 7D Mark II, 12

 changing, 72–74

 explained, 70

 landscape vs. portrait mode, 77–78